WATERTOWN SQUARE

THROUGH TIME

CARA MARCUS

AMERICA
THROUGH TIME®
ADDING COLOR TO AMERICAN HISTORY

America Through Time is an imprint of Fonthill Media LLC
www.through-time.com
office@through-time.com

Published by Arcadia Publishing by arrangement with Fonthill Media LLC
For all general information, please contact Arcadia Publishing:
Telephone: 843-853-2070
Fax: 843-853-0044
E-mail: sales@arcadiapublishing.com
For customer service and orders:
Toll-Free 1-888-313-2665

www.arcadiapublishing.com

First published 2018

ISBN 978-1-63500-063-4

Typeset in Mrs Eaves XL Serif Narrow
Printed and bound in Great Britain by CPI Group (UK) Ltd, Croydon CR0 4YY

Introduction

The heart of Watertown Square is its Delta. Watertown designated precincts in the 1900s—precinct 5 was the "principle mercantile section." Many of Watertown Square's early stores and even entire blocks like Barnard Block were demolished and replaced by the beautiful stretch of lawn, trees, and flowers where the Square's streets coalesce. It was once stipulated that no structure be erected in the Delta besides a flagpole. During recent flagpole renovations, workers uncovered layers of asphalt and bituminous concrete, and even the granite foundation of an old building, unearthing centuries of history.

Watertown Square has been a hub connecting other cities, even in colonial days. During a recent excavation to make way for new businesses, horseshoes from the early days were uncovered under Arsenal Street. In winters long-gone, traffic passed on sleighs. Today's electric bus service is one of a few hundred throughout the world. Many residents remember the rotary in Watertown Square. Traffic proceeded counterclockwise, sometimes quite slowly. John S. Airasian wryly recalled, "Some people liked it and some people didn't," and Pat Stenson exclaimed, "Somehow you always got through!" When the rotary was removed, a tank from the Watertown Arsenal was called in for the job.

If the Delta is the Square's heart, the Charles River is its pulse. To the west are the falls and fish weir. The weir was built in 1632 and was abundant with shad used for manure by farmers who learned from the Native Americans. Waterways including Smelt Brook and Laundry Book once flowed through the river. The Town Landing where Sir Richard Saltonstall first glimpsed Watertown now furnishes the dock where new generations come to fish. The Charlestown Ferry traveled from Watertown Square to Boston in the eighteenth century and the Boat Elk made sightseeing trips in the 1900s.

Though as walkable today as it was 300 years ago, many streets of Watertown Square have changed. Some streets were named for a landmark. Starch Factory Lane was named for the Starch Works; Baptist Walk was named after the Baptist families who built their first meetinghouse there. California Street was once South River Street, Merchant's Row was Main Street Court, and Pleasant Street was Back Road. New roads have been added, such as Nonantum Road in 1927. Other streets are mere memories, such as Cambridge Port Road and Mill Dam Road. Individual buildings and blocks have been named after Watertown's prominent citizens—Kelley's Corner, Whitney Block, Otis Building, and Winnick Building.

Many townsfolk remember simpler times in Watertown Square. Charlie Calusdian recalls his uncle driving an open wooden truck filled with vegetables from the market to folks' homes. Bob Manzelli remembers taking his children every year to the tree lighting ceremony. John Kilcoyne recollects being entertained by hundreds of herring leaping over the falls.

The Square has its share of interesting stories—Spring Hotel visitors believed it to be haunted (the "ghost" was merely a cloth on a post). The parking lot built on railroad station property was said to once be an aqueduct. In the 1960s, a loud siren would sound every Friday at noon. Now beautiful public murals can be viewed in Merchants Row and the "Tapestry of Cultures" along Baptist Walk. Watertown Square has been the venue for the Make Way for Ducklings Walk, Walk for Hunger, September 11 public observances, and Armenian Genocide and Hiroshima atomic bombing anniversary commemorations.

The story doesn't end here—a time capsule was buried in 1975 in front of the Administration Building to be opened in the year 2030 on Watertown's 400th birthday. *Watertown Square Through Time* will lead you on a journey starting out with the Square from the air, followed by the Delta, the Charles River, Main Street and adjourning roads, and transportation, special monuments and events in Watertown Square. Are you ready to take a walk through Watertown Square? Let's go!

ACKNOWLEDGMENTS

Sincere appreciation for the many organizations and individuals who have shared their photographs, stories, and memories of Watertown Square used in this book—John S. Airasian, Marion Amato, Carol Smith Berney, Boston Public Library, Charlie Breitrose, Edmund (Ed) Caggiano, Rose Caloiero, Charlie Calusdian, Lisa Casale, Elaine Cohen, Leone Cole, Paul Cram, Kelly Cronin, Virginia (Ginnie) Curcio, Daderot, Ann Davis, Mike DeAngelis, Andy Dincher, Maureen Doherty, Dan Driscoll, Pat Farrell, First Parish of Watertown, Sean Fisher, Rubi Galui, Mark Harris, Donald M. (Don) Hawes, Ellen Hayes, Christopher Hayward, Hannah and Sasha Helfner, Amy Hughes, Carole Katz, Joyce Kelly, Pat Kelly, John F. (Jack) Kilcoyne, Angeline B. Kounelis, T. Koei Kuwahara, Andrea Lanno, David F. Lawlor, Michael Lawn, Library of Congress, Gary Lind-Sinanian, Marc Lucas, Joseph P. (Sandy) MacDonald, Murray MacLean, Robert A. (Bob) Manzelli, Tom Manzelli, Ingrid Marchesano, Ed Marcus, Massachusetts DCR, Jason Mavor, Susan Michals, Charles (Charlie) Morash, Karl H. Neugebauer, Bernie O'Reilly, Roger Puta, Bob Quinn, Marilynne K. Roach, David J. Russo, Juan Salmeron, Kevin Sanderson, Gideon Schreiber, Peter Seminara, Patricia (Pat) Stenson, Raya Stern, David Strati, Moe Taha, Mohsen Tehrani, Stephen Tresca, Karen Ucuz, Watertown Autism Family Support Group, Watertown Fire Department, Watertown Free Public Library, Watertown Historical Society, Watertown News, Watertown Police Department, Watertown Savings Bank, Watertown Women's Club, Stephen M. Winnick, Mandy Wong, and Ramone Zarazua. And thanks to *everyone* I spoke to in conjunction with this book, for permission to include their buildings, grounds and events.

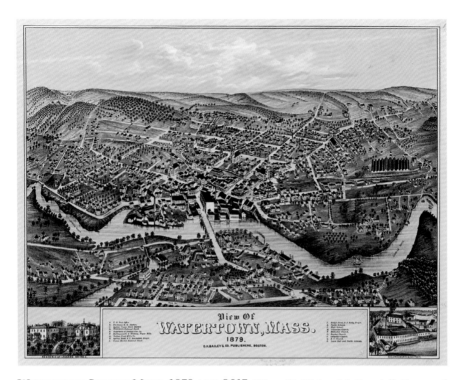

WATERTOWN SQUARE MAPS, 1879 AND 2017: When Sir Richard Saltonstall, Reverend George Phillips, and their companions, servants and livestock traveled along the "Charles Ryver" in 1630 looking for a fine place to settle, they discovered a landing in a place they named Watertown. This early Watertown subsequently became part of Cambridge when boundary lines were shifted. It has been said that the town was named after the abundance of "fine springs" in the area. Some of the early place names have remained, such as Baptist Walk, and, of course, the Watertown Delta. The 1879 Map by O. H. Bailey & Co. is a remarkable illustration that details the factories, churches, and town offices in the Square, and the 2017 map is a modern rendering from the Watertown Department of Community Development & Planning.

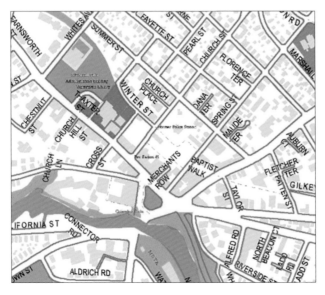

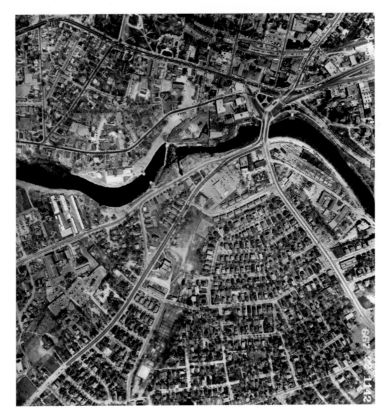

WATERTOWN SQUARE AERIAL VIEWS, 1956 AND 2015: The top photograph taken by Aero Service Corp. in 1956 is courtesy of the Massachusetts Department of Conservation & Recreation Archives and the bottom one was taken in 2015 by the Watertown Community Development & Planning Department. The older photo shows a delta divided by paths, nearby commercial buildings, a rotary for traffic, and a triangle near the delta. Much has changed in Watertown Square over the past sixty years and the modern photo shows none of these, but the quaint street name Merchant's Row still remains.

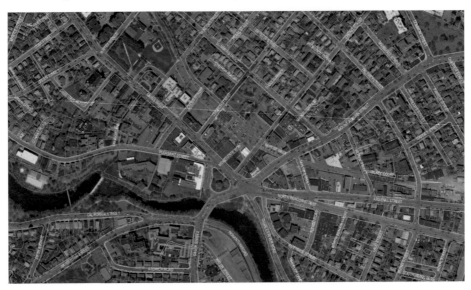

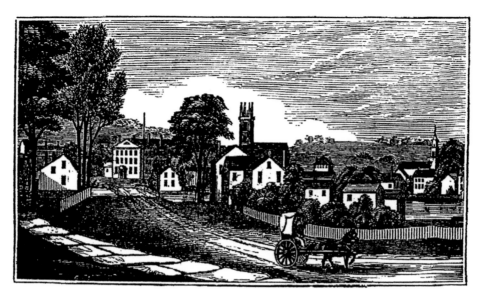

BIRD'S EYE VIEW, PRE-1840 AND 2017: Before Watertown Square had a square or even a delta, it was known as "The Marketplace." Historian Salon Franklin Whitney, speaking of Watertown Square in the 1800s, declared it, "a lively spot and the merchants did a thriving business." With a slaughterhouse, two distilleries, and a Japan tea store (that sold eggs and creamery butter in addition to tea), the Square of the 1800s was a center of commerce and industry. A resident walking through Watertown Square in 1840 exclaimed, "The sun was well up ... good old fashioned dwellings such as the times called for, with their owners and occupants just starting out on their daily business, made to me one of the finest views I have ever seen." The dirt roads in the top illustration have all been widened and paved and the foot bridge that was crossed by pedestrians and horses alike was succeeded by the Galen Street Bridge, shown behind the flag in the bottom image.

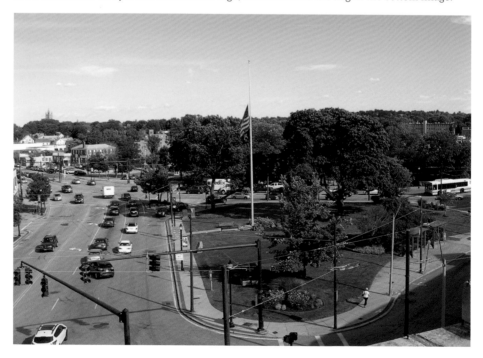

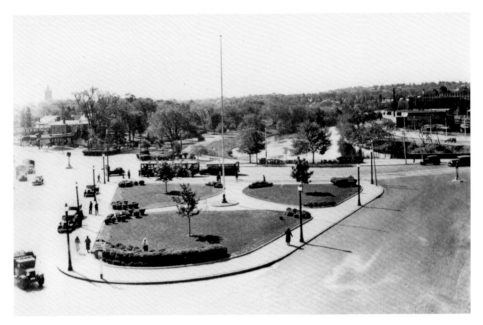

BIRD'S EYE VIEWS, 1930 AND 2017: Watertown Square, Watertown Delta, Watertown Rotary—it's been all of those. Before there was a Delta, there were three parts of Watertown, the East End, the West End, and the "Middle Part," which became the Delta and the Square. In 1909, the only embellishment allowed in the Delta was a public water fountain, donated by the Women's Christian Temperance Union and later laid in concrete. The fountain was moved from the Square in the 1920s and the Delta and its flagpole were dedicated by the town in 1927. It's difficult to imagine a trolley stop in the middle of the Galen Street Bridge as shown in the top photograph—now both buses and taxicabs pick up passengers in a dedicated area between the Delta and Riverbend Office Park. The bottom image was taken from the roof of the Watertown Savings Bank building and shows a lusher, more park-like delta then a century ago.

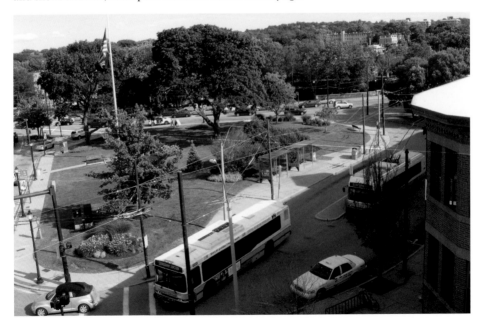

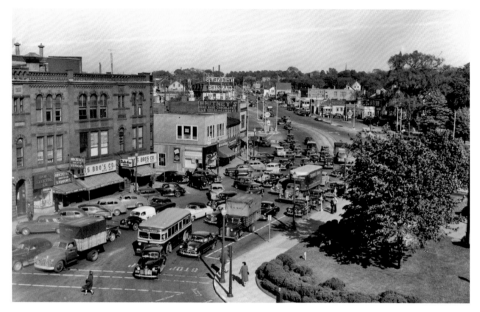

BIRD'S EYE VIEWS, 1950 AND 2017: It was a busy day indeed in this 1950 view of Watertown Square from retired police detective Peter Seminara's photograph collection. Businesses included Whitney's Candies, Hawes Electric, Hackett's Liquors, Otis Brothers Co., and Aggie's Cab. Note the Main Street angled parking and wooden mail trucks in the older image. Whitney's Confectionary, also known as Whitney's Candy Kitchen, served homemade chocolates since the early 1900s. The site later became Lauricella's Spa and Vivian Manhattan Jewelers, and is currently H&R Block and Trevens Specific Chiropractic. Old-timers reminisce about overhead tracks where money from sales would roll to the bookkeeper, who would roll change back to the sales clerk. Another reason to visit was a "newfangled contraption" where you put your feet under a light and saw your bones. During the 1970s, the Otis Brothers Men's Store was still in business. None of the same businesses still exist in the modern picture, and stately trees flank the Otis Building instead of parked cars.

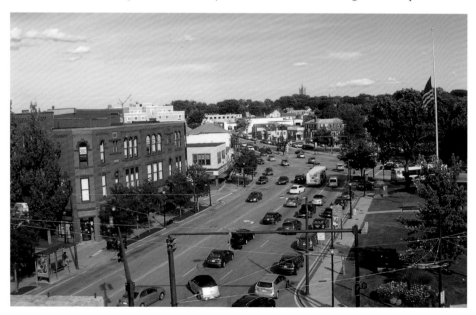

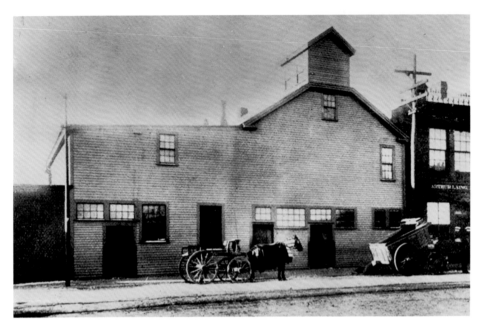

GRIST MILL TO WATERTOWN DELTA: In 1634, Thomas Mayhew owned a mill at Mill Creek near the falls. The Grist Mill was one of the first mills of its kind in America and held the first right in America for use of water for power. Farmers far and wide brought their grain to be ground at the mill. In later years, that mill became known in Watertown parlance as the "Ancient Grist Mill." The mill was moved closer to Watertown Square in the 1670s to 18 Main Street opposite Spring Street, as shown in the image above, and was operated by Coffin & McGee and by Perkins & Company. The mill operated until 1898, was demolished in 1906 as part of the widening of Galen Street, and the site eventually became the Columbus Delta as part of the Metropolitan Parks Commission. While wheat, rye, and corn are no longer ground into flour, the Delta boasts an assortment of fine trees, bushes, and plantings.

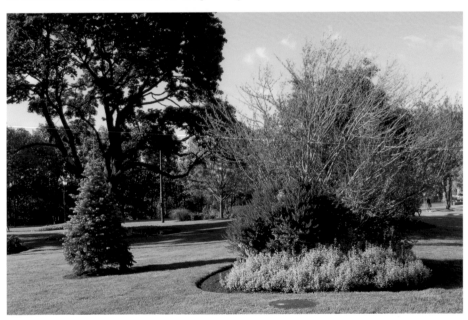

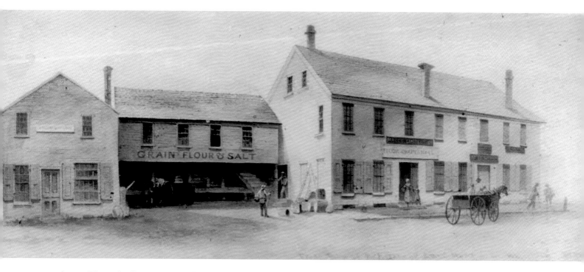

ABEL HUNT'S STORE AND TRULL'S MARKET TO DELTA: Watertown once had two squares! However, Beacon Square was not the same as Watertown Square, even though they were very close together. Some of Beacon Square's tenants were Abel Hunt's Liquor Store and Thomas Trull's Fish Market (shown in the top photograph), Magee and Lindley's Grocery, J. Albert Sullivan's Drug Store, Boston Branch Grocery, J. F. Nolan Horse Shoeing, and Simpson Brother's Grocery. Watertown resident Felix A. Leonard, born in Watertown in 1905, remembered the large watering hole for horses in the center of Beacon Square when he was a child. Alas, Beacon Square was reconstructed by the Metropolitan District Commission (which became the Department of Conservation & Recreation) to make way for bridge and road widening—no trace of it remains. What was Beacon Square is now the Watertown Delta, which makes the goslings in the bottom photograph quite happy.

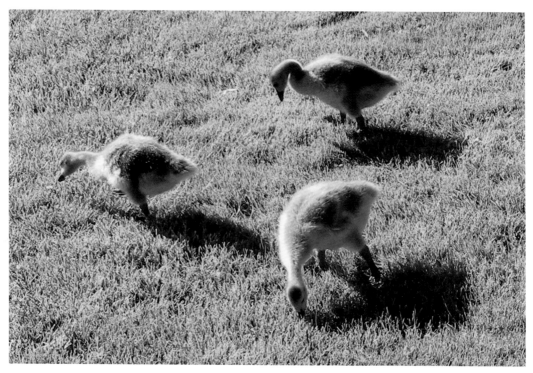

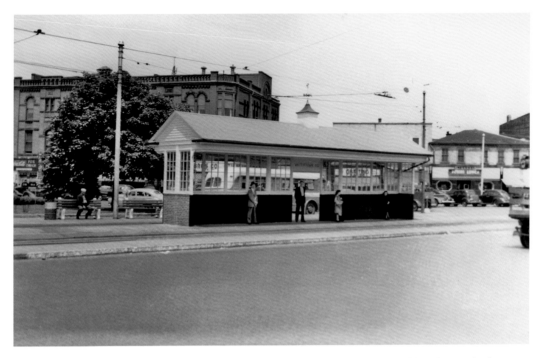

POLICE BOOTH TO DELTA: During the mid-1900s, police manned two traffic control booths, one in the middle of Watertown Square and one on Galen Street right before the Square (as shown in the top scene from retired police detective Peter Seminara's photo collection), where traffic officers directed traffic around the rotary. These booths were rolled out on wheels during high traffic periods. In 1966, it was estimated that 69,838 vehicles passed this intersection daily. Both the rotary and the traffic control booths are long gone, and the trees in the Delta have flourished thanks to tree warden Christopher Hayward and staff.

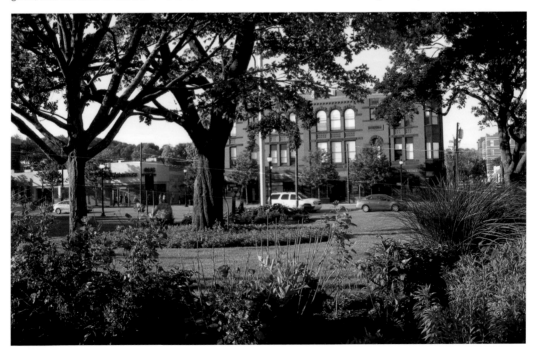

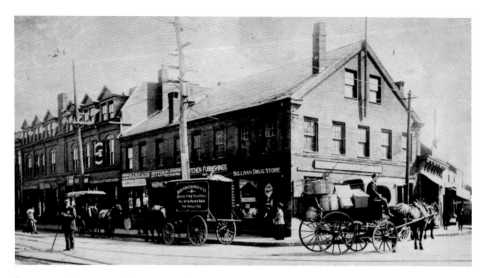

BARNARD BLOCK TO DELTA: Built in 1824 and razed by the town in 1925, Joel Barnard Jr.'s Barnard Block that spanned 26 Main Street to Galen Street had been home to Damon and Psomos Confectionery and Fruit, Robert J. Graham Undertaker, J. Albert Sullivan Drug Store (which provided apothecary service and filled prescriptions all hours of the day or night), I. W. Pinkham's Dry and Fancy Good Double Store, George H. Tarlton Watchmakers and Jewelry (French clocks a specialty), and S. E. Ripley's Fine Custom Tailoring. Fred J. Barker established himself at Barnard's Block in 1879 and commenced printing of the *Watertown Tribune-Enterprise* ("The Home Paper," published every Wednesday and only $1.25 per year) and the journal *Ornithologist and Oölogist*. The Post Office was situated there in the late 1800s and the Young Men's Catholic Association held meetings there. The Columbus Delta exists now where the block once stood. In 1939, the town voted to name the Delta the Columbus Delta after the Knights of Columbus, and a plaque was installed in 1940.

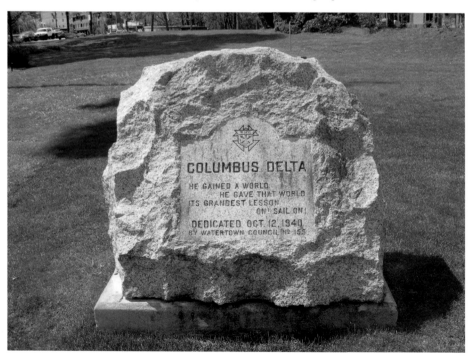

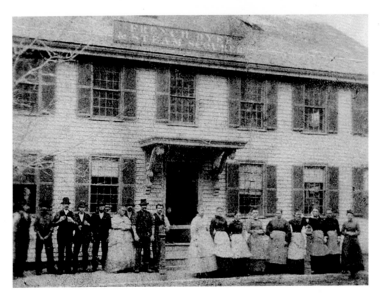

LEWANDO'S TO RIVERBEND OFFICE PARK INTERIOR: Lewando's was established at 1 Galen Street in 1828 by James McGarvey, who had a dye house on the property called the Watertown Dye House. The business was moved to Maine, then Dedham, Mass., and then owner Aldolphus Lewando moved it back to its birthplace on Pleasant Street near Galen Street in Watertown. Their advertisements quoted Shakespeare, "Out, damned spot!" Watertown residents could tell what color dye was being used that day by the tinge to the Charles River. Lewandos (they dropped the apostrophe to modernize the name) closed its Watertown Square location in 1969. The top photograph displays the earliest Lewando's building and many of its workers, but the bottom one contains a surprise. When the Riverbend Office Park was constructed on the Lewandos site, the architects wanted to preserve as much as they could of the brick-and-beam ambiance. The image shown below is a full building from the 1800s that was preserved, restored, and located completely inside the office park, with the only modern touch a large computer screen near the door.

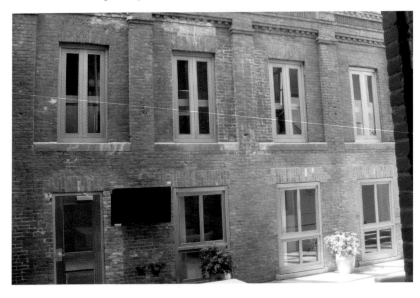

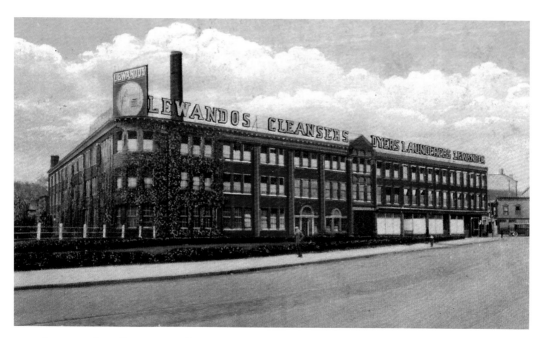

LEWANDO'S TO RIVERBEND OFFICE PARK AND TAXIS: Lewando's was once the largest business of its kind in the country. By the end of the nineteenth century, workers turned out about 4,500 collars and cuffs each day. Its four buildings known as the River House, the Galen House, the Pleasant House, and the Courtyard House were merged to form a U-shaped structure. The site underwent a renovation in 1987 and now the Riverbend Office Park fronts a taxi and MBTA bus waiting area. Riverbend Office Park leases space for many businesses, including Pathfinder International, Families First, and a number of technology companies. Watertown Taxi (The Blue Cab) is shown in front of the building in the modern photograph. A Watertown Taxi driver remembers his furthest fare from Watertown Square, all the way to Foxwoods Casino in Connecticut (and the passenger did not ask for a return trip)!

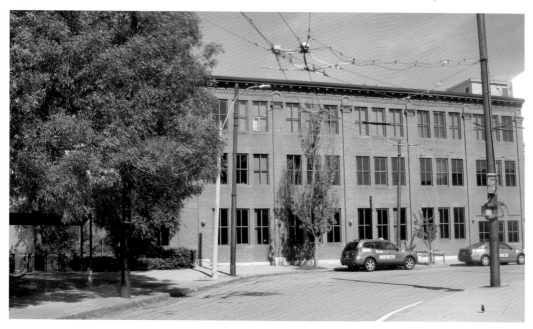

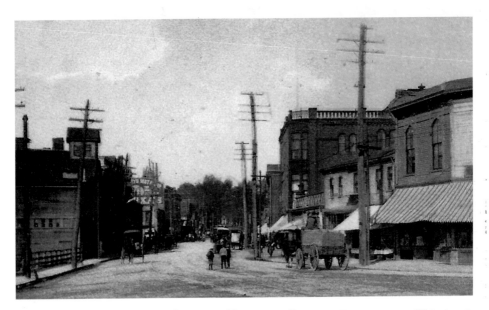

HORSES AND BUGGIES ON MAIN STREET TO HISTORICAL BANNERS: For many years, Watertown's Main Street was one of the few roads connecting Boston with cities to the West and South. The road was called the Colonial Highway, Old Connecticut Road, George Washington Memorial Highway (a plaque was installed commemorating this name on the Watertown Savings Bank building in 1932), and Sudbury Road—Native Americans knew it as The Old Trail. Townsfolk shared the road with mail and stage coaches, country wagons, and droves of cattle. In the early 1900s, the only part of Main Street that was tarred was the area between Spring and Church Street—the rest was a dirt road. Every Sunday at 4:00 AM, Peter Whitney would wash the tarred part of the street with water from the hydrant. The Otis Building (the brown building on the right) is still recognizable, but the Grist Mill (in the lower left of the top illustration) has been replaced by the Delta. A historic banner donated to the town by the Rotary Club welcoming people to Watertown Square and Main Street evokes a sense of the past.

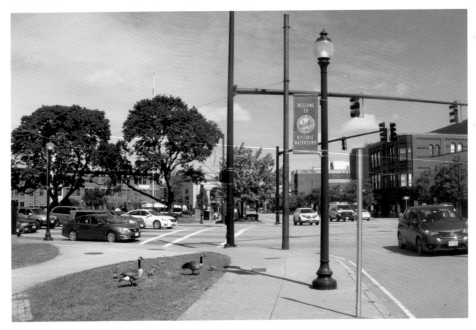

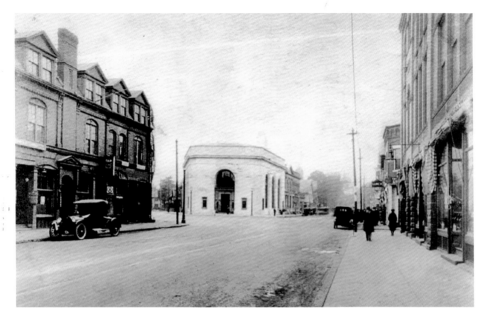

UNION MARKET NATIONAL BANK AND BEACON SQUARE TO WATERTOWN SAVINGS BANK AND RIVERBEND OFFICE PARK: The Union Market National Bank was founded by Charles J. Berry, Royal Gilkey (owner of the Royal Gilkey Wood and Coal Company), George K. Snow, George N. March, Thomas L. French, and James S. Allison in Watertown Square's Bond Building opposite Town Hall in 1873. In 1921, the bank moved the corner of Main and Pleasant Streets. The top photo from 1925 also shows Beacon Square to the left, which occupied the space where the Watertown Delta is now. Streets that flanked Beacon Square were Main Street, Mount Auburn Street, Arsenal Street, North Beacon Street, and Riverside Street. Today's Watertown Square branch of the Watertown Savings Bank (incorporated in 1870, shown in the bottom photograph) is open Monday through Saturday and provides a night depository. In the early days, the Watertown Savings Bank was open from 1-4 PM every day, and also on Thursdays from 7-9 PM.

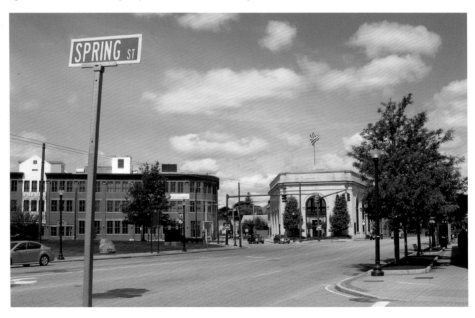

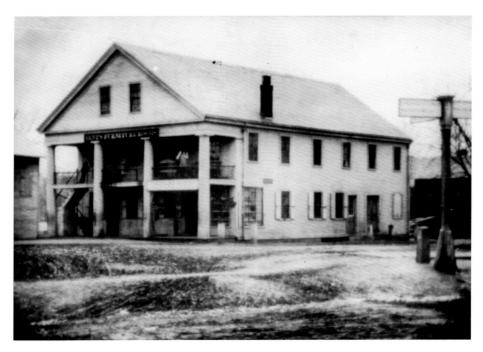

KENT'S FURNITURE TO WATERTOWN SAVINGS BANK GARDEN: Kent's Furniture was originally at the corner of Galen and Pleasant Streets (as shown in the above photograph), then moved to Main Street opposite Church Street. The name of the original store was Kent's Furniture Rooms Building. Mr. Kent peeks out of the second-floor balcony in the older photograph. The beautiful flowers displayed in the bottom photograph in the area where Kent's Furniture once stood are provided and maintained by the Watertown Savings Bank.

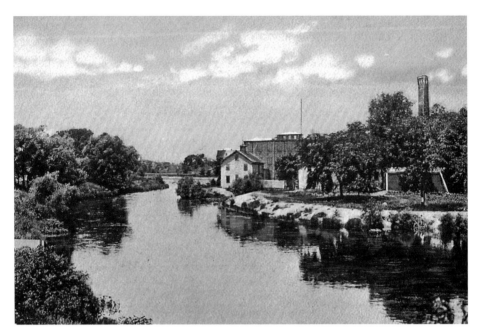

CHARLES RIVER: The Charles River, called the Big Eel by the area's Native Americans, was named for Britain's King Charles I, who gave his royal seal to a charter that permitted exploration and colonization of the New World. In 1614, the river had been named the Massachusetts River by Captain John Smith, after the Massachusett Indian tribe who lived there. The river's ancient name was the Quineboquin. The top photograph from the 1800s shows some of the many homes and factories built along the river. Some still exist, but the trees have grown so that they are difficult to see. In the bottom photograph taken by nature photographer Carole Smith Berney, showing the same view from the Galen Street Bridge looking west, you can see the original exquisite beauty of the river that awed the first settlers.

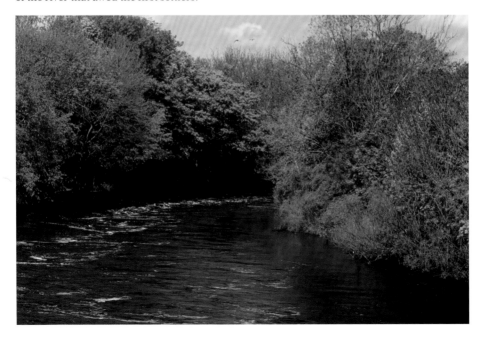

HOSMER HOUSE TO CHARLES RIVER APARTMENTS: Sculptress Harriet Hosmer lived in a lovely house right on the Charles River, with clapboards, black blinds, a fan-shaped front door, and leaded glass panels. The Hosmer family lived on Riverside Street next to Reverend Convers Francis' House. In 1880, Harriet Hosmer sold the house and land to her cousin Alfred, founder of the Watertown Historical Society and one of the namesakes of the Hosmer School, for $500. Neighbors remembered a friendly cow stationed outside the Hosmer house, feasting on the grass on the front lawn. The house and neighboring homes were replaced by apartment buildings in 1960.

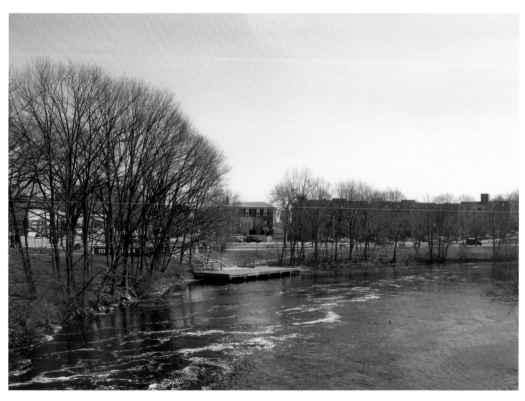

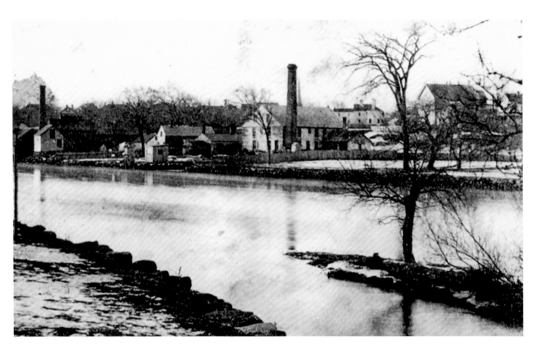

MILL CREEK 1865 TO MILL CREEK SIGN 2017: A stone dam was built by hand by Seth Bemis in 1822, and a canal, Mill Creek, bore water from above the dam. Mill Creek ran along Pleasant Street to Main Street, joined Treadway Brook, which ran along Spring St. and met the river near the Town Dock. There was also mention of Treadway (also called Treadeway) Square and Bridge in the early 1800s town records. The road leading from the mill was also named Mill Creek, which later became Mount Auburn Street. The top photo shows part of Mill Creek near Town Landing and the surrounding structures in 1865, and the bottom displays the sign on the south side of where the creek once ran, commemorating Mill Creek's place in history.

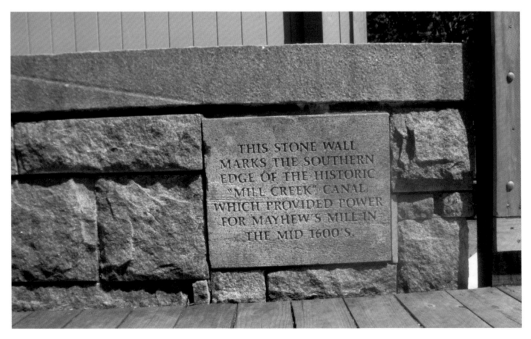

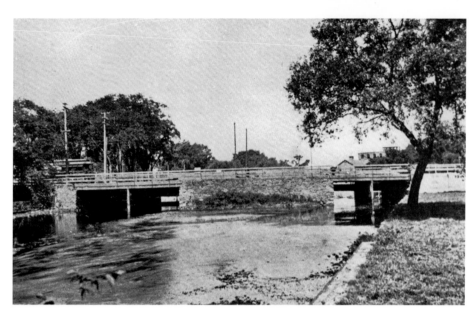

GREAT BRIDGE TO GALEN STREET BRIDGE: The Great Bridge was a very great bridge indeed, and it had a great many iterations as well. It was also called the Galen Street Bridge, Nonantum Bridge, and Railroad Bridge. The first bridge in Watertown Square was constructed in 1614. A footbridge was built on Galen Street over the Charles in 1641. A granite tablet was inscribed on the side with, "The old bridge by the mill crossed Charles River near this spot as early as 1641." Workmen building the bridge in 1647 were paid partially in wine. In 1666, the bridge collapsed due to ice, and a new bridge was built in 1667 out of wooden boxes filled with stones, and passers were charged a toll to cross it. A new, 90-foot long, wood, granite and steel Great Bridge was constructed in 1719. The bridge we have now in Watertown Square (shown in the postcard below when it was fairly new) was built in 1907 from reinforced concrete and granite from Maine, with four standing balconies and overhead lights.

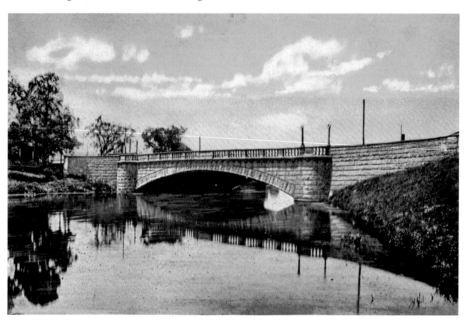

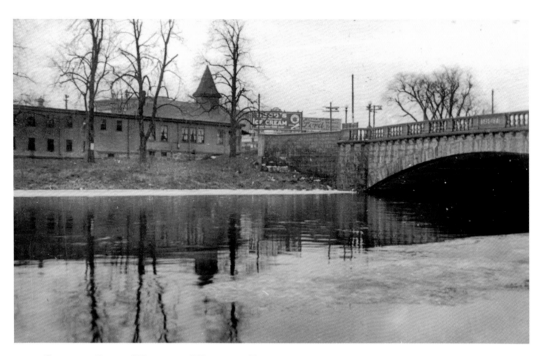

CHARLES RIVER WITH AND WITHOUT BILLBOARDS: Watertown Square used to be a mecca for billboard advertising. From the earliest days of billboard art, everything from Bushway Ice Cream to Hood's Ice Cream to Whitney's Kisses to Ford automobiles was advertised to the drivers navigating the streets converging in Watertown Square. The initiation of the removal of what some in the town called the "unsightly billboards" in Watertown Square was commenced in 1987, and now nary a billboard can be seen in the Square. Another difference between the top and the bottom photographs is changes to many of the buildings on Galen Street seen to the right of the bridge.

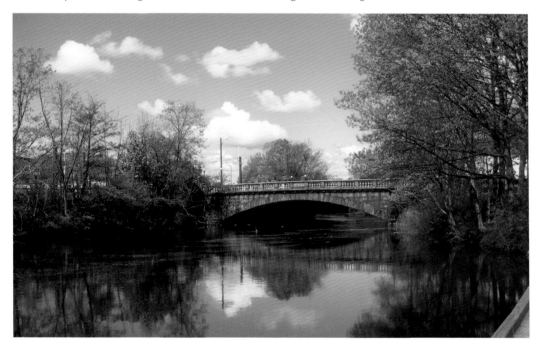

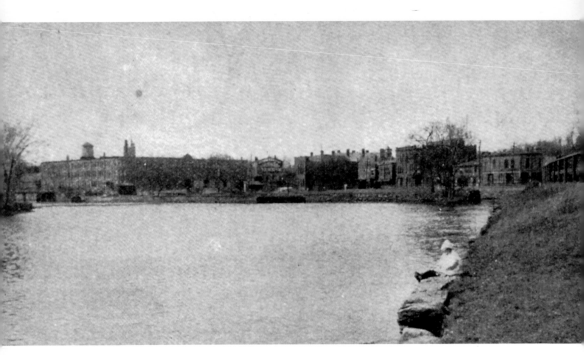

CHARLES RIVER DOCK, 1907 AND 2017: When Watertown was colonized in the 1600s, the river was ablaze with shad, alewives, and herring. Today the river is swimming with bass, pike, shad, sunfish, and carp. John S. Airasian, a Watertown resident since 1943, remembered fishing for perch in the 1950s with his father Peter Airasian, and is happy to see that bass have returned to the Charles River dock area, where his grandchildren now fish. In the top photo from 1907, a child sits and gazes out on the beauty of the River from the landing. In the bottom photo 110 years later, firefighter Kevin Sanderson proudly holds up his catch of the day, which he then threw back into the river so the tiny shad could continue to swim and grow.

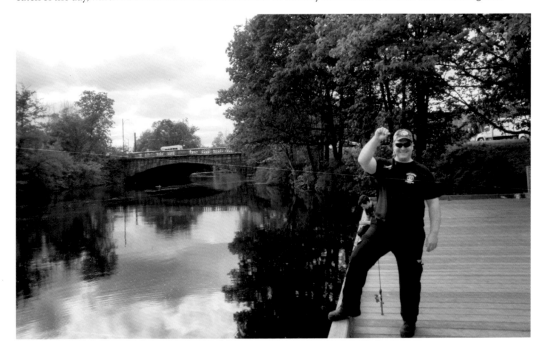

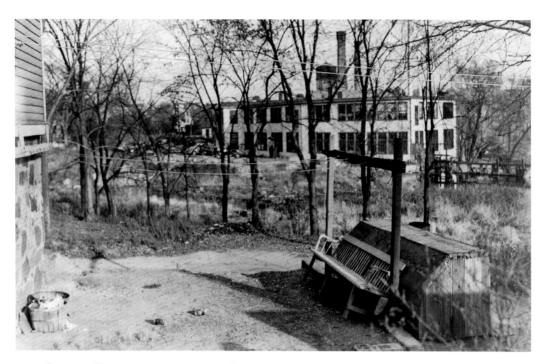

CHARLES RIVER BEFORE AND AFTER RESTORATION: The Department of Conservation & Recreation's Charles River Restoration in 2006 dramatically changed the landscape of the River and the Greenway (definitely for the better), including creation of brand new walking trails. The 1936 top photograph (courtesy of the Massachusetts Department of Conservation & Recreation Archives) was a proposed site for a Watertown Square bathhouse with a view of a dilapidated, once-majestic mill building, and the bottom photograph shows the same area in 2017, alive with natural beauty surrounding scenic walking and cycling trails.

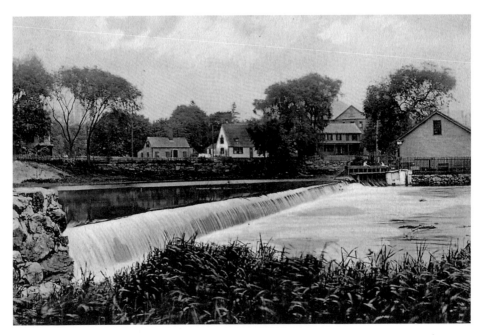

PAPER MILL FALLS TO WATERTOWN DAM: William May opened a first paper mill at 36 Pleasant Street in 1839. Through the years, the mill was known as Leonard Whitney & Son, Whitney & Priest, Whitney Paper Mill, and Union Paper Bag Company, who remained there until 1911. The falls used by the mills have always attracted visitors by their grandeur and power. John Kilcoyne, owner of H & K Insurance, remembers standing with his friends in the 1940s and being entertained by hundreds of herring leaping over the falls. The falls are no longer called Paper Mill Falls—they are known as Watertown Square Falls or Watertown Dam. As shown in Andy Dincher's contemporary photograph, the stone wall flanking the falls in the 1800s illustrated in the top image has been replaced by concrete, houses are no longer visible along the bank, and the trees have certainly grown in the area. However, the falls themselves remain as magnificent and breathtaking as ever.

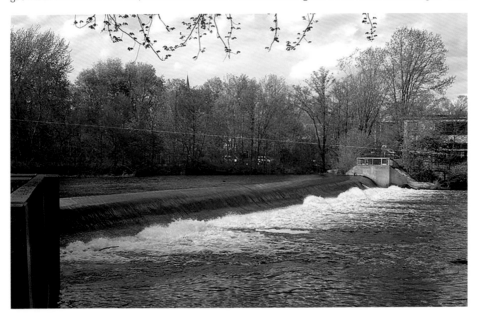

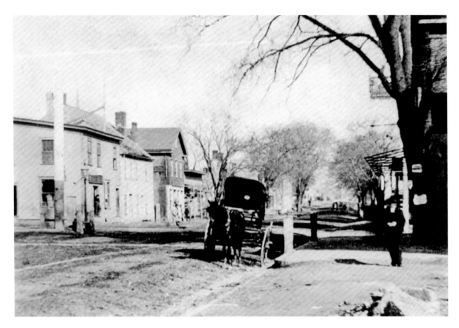

OLD TOWN PUMP TO FIRE BOX: The Old Town Pump was a drinking fountain that stood in the middle of Main Street opposite Galen Street during the 1800s. Reverend James E. Norcross declared the pump a "much used handle and generous trough was an ever-inviting spectacle for man and beast." In 1887, the town pump was consigned to the fate of many venerated though obsolete things of the past and was removed. The same year, a new drinking fountain was erected in Beacon Square, thanks to a generous donation by public servant William H. Ingraham, Esq. That fountain also was eventually removed, along with the entire Beacon Square. The bottom photo doesn't show a pump, but the active fire box can be used to alert the fire department about the location of a fire, potentially bringing on firefighting pumps and water. While some may feel that cell phones have rendered fire boxes obsolete, the boxes are still in use in many areas today.

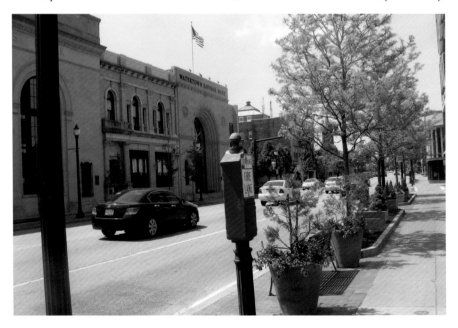

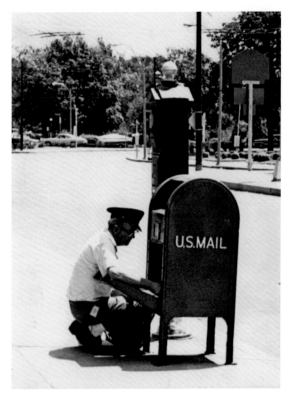

MAIL CARRIERS, 1960 AND 2017: In the photo (left) from 1960, a postal worker emptied a mailbox on Main Street across from the Galen Street Bridge and Pleasant Street. The bottom photo shows postal worker Eric Manning delivering mail in 2017 in the same area. The mailbox was moved slightly closer to the Square in front of the CVS, but the fire box remains, and the enchanting flower display takes the place of the mailbox. While postal uniforms and hats may have changed over the past sixty years, "Neither snow nor rain nor heat nor gloom of night stays these couriers from the swift completion of their appointed rounds".

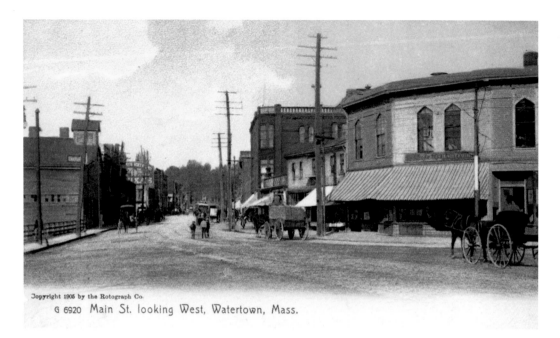

Copyright 1905 by the Rotograph Co.
G 6920 Main St. looking West, Watertown, Mass.

GRAND ARMY HALL TO NOVUS MED SPA AND SKINCARE: The Grand Army of the Republic Hall where Civil War veterans gathered was on the second story of the wooden building on the corner of Mount Auburn Street and Main Street. The hall was known as both the Grand Army Hall and the G. A. R. Hall and was also called Forester's Hall. The Good Shepherd Parish held their services there from 1883-1888 amongst the flags and guns on display. The Watertown High School senior class of 1902 enjoyed a "very pleasant" senior class party at the hall, where they were entertained by the School Quartette. The top image shows the hall in 1905. Today, the second story of 2 Mount Auburn Street where the Grand Army Hall once existed is Novus Timeless Med Spa and Skincare, which opened in 2016 under the ownership of Carina Su. Before Novus opened, the site was a physician's office.

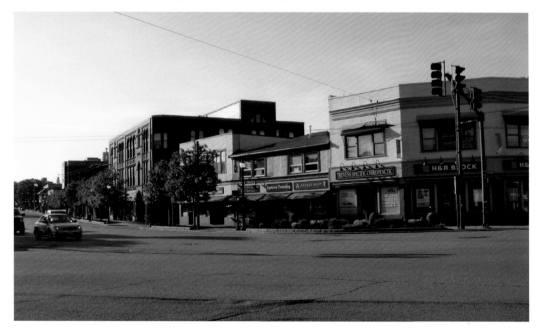

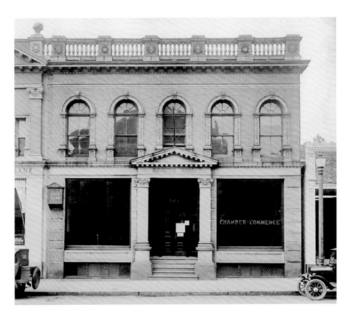

CHAMBER OF COMMERCE TO WATERTOWN SAVINGS BANK: The Watertown Belmont Chamber of Commerce has had many homes, and the Boston Chamber of Commerce even had an office in Watertown in the distant past. In the 1930s, the Watertown Chamber of Commerce headquarters was at 17 Main Street. At one time, the Watertown Chamber of Commerce used space at 56 Main Street in the former Watertown Cooperative Bank (as shown in the top photograph), then set up offices in the basement of what is now the Santander Bank Building at 75 Main Street in the early 1980s, and resided as the Watertown Belmont Chamber of Commerce from 1980 to 2017 at 182 Main Street. Watertown Savings Bank (shown in the bottom photograph) resides in the former Watertown Cooperative Bank space. H & K Insurance Agency and Mavor Chiropractic now stand at 182 Main Street. At the time of this writing, the Watertown Belmont Chamber of Commerce's home is on the Internet where it continues to produce a valuable member directory and host a variety of creative neighborhood services, initiatives, and events.

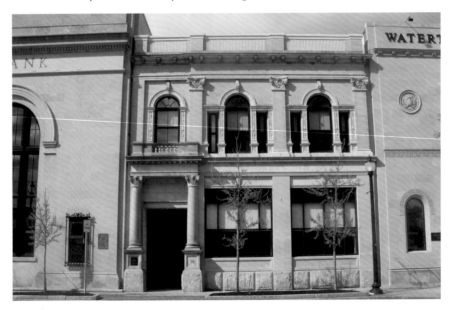

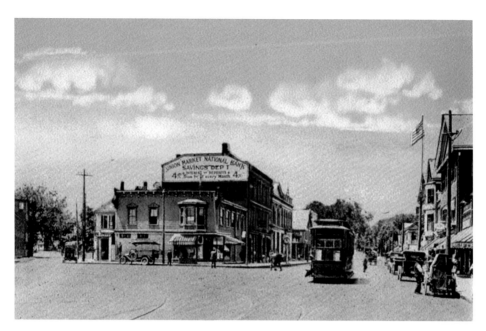

UNION MARKET NATIONAL BANK TO WATERTOWN SAVINGS BANK: Bank signs have always been a theme in Watertown Square. In the top illustration from 1910, the Union Market National Bank proudly advertised their 4-cent interest on deposits on the side of their building. Charles W. (Charlie) Morash was the Union Market National Bank's vice president and oversaw the building of the marque-like sign that lit up Watertown Square for events like National Library Week. The building once occupied by the Union Market National Bank is now home to the Watertown Savings Bank. The bottom photograph shows a Main Street view of the Watertown Savings Bank heralding something different than interest rates, the New England Patriots' NFL championship.

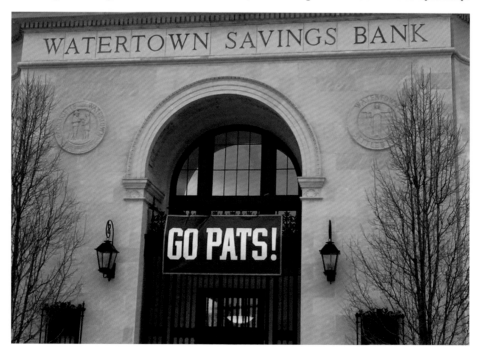

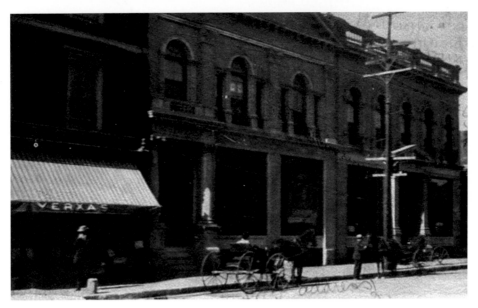

YERXA'S TO WATERTOWN SAVINGS BANK: Yerxa's Groceries was originally located at 50 Main Street in the 1800s and moved to 14 Mount Auburn Street in 1926. The top photograph from the Charlie Morash photograph collection shows the original 50 Main Street Yerxa's location, which is now part of the Watertown Savings Bank. A Mount Auburn Street building is still named the Yerxa Building, with lettering inscribed into the brickwork on the Mount Auburn Street side and a door sign at 10 Mount Auburn. The Watertown Savings Bank was incorporated in the Noyes Building at 56 Main Street in 1870. Deposits for the first day amounted to $924. In 1875, the bank moved to the McMasters Block at 26 Main Street, and back to 56 Main Street in 1880, this time to the Bond Building. After one more move back to 26 Main Street, which was called the Barnard Block in 1886, the bank moved into its permanent home at 60 Main Street in 1891. While much of the architecture of the center Watertown Savings Bank building remained, the homey Yerxa's awning was quite different from the sweeping arched window that graces the Watertown Savings Bank of today.

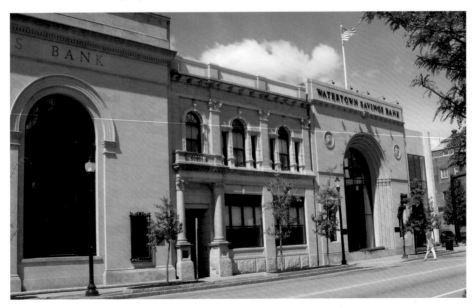

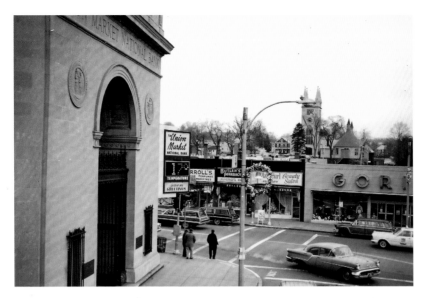

UNION MARKET NATIONAL BANK AND MAIN ST. STORES TO WATERTOWN SAVINGS
BANK AND GARDEN: The top photograph from the Charlie Morash collection
shows Union Market National Bank in all its holiday glory, with "Seasons Greetings"
welcoming shoppers underneath its time-and-temperature sign on a very chilly
17-degree day. Mid-twentieth century shoppers had their choice of Gorin's, Butler's
Pharmacy, or Carroll's Perfumes, and Play-Curl Beauty Salon was ready to style their
holiday hairdo. Gorin's Department Store at 39 Main Street outfitted generations of
Watertown residents with children's and adults' clothing, uniforms, and linens in
the mid-twentieth century through the 1970s. The bottom photograph from 2017
shows a similarly situated view of Watertown Savings Bank and their pretty garden
area flanked by evergreens. Many Watertown residents remembered the Norway
maple tree planted near the bank around 1927, which grew as tall as the bank and
was lit during the holidays. At one point, it was split right down the center during a
thunderstorm. That majestic tree provided beauty and shade until 2015.

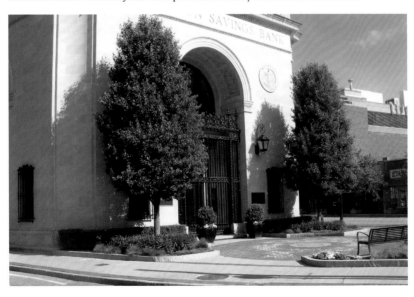

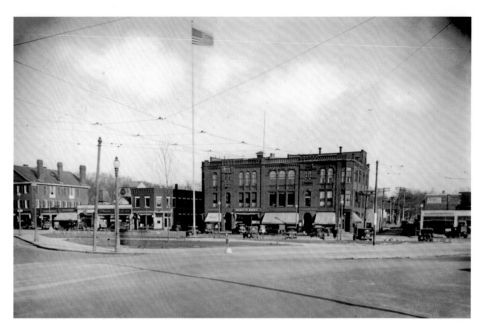

OTIS BUILDING, 1920S AND 2017: The Otis Brothers Block, named after brothers Horace W. and Ward M. Otis, at one time spanned 1-13 Main Street and 2-4 Mount Auburn Street. During the 1800s, the Otis Building was also home to the YMCA, the Lodge of Freemasons, Plaisted & Eames Provision Dealers, and Woodward's Apothecary Store. The *Watertown Tribune Enterprise* newspaper at one time operated out of 17 Main Street. During the 1920s, Otis Hawes of Hawes Electric Company purchased the Otis Block and renamed it the Hawes Block in 1929. Otis Realty was incorporated at 17 Main Street in the Otis Building in 1987; though not by any decedents of the Otis family, and the business took on the name from the building. The Otis Building is considered a historic property by the Massachusetts Historical Commission. The building is now home to a variety of businesses, including the UPS Store, Koltun Ballet, All Dental Center, and Uniforms for America.

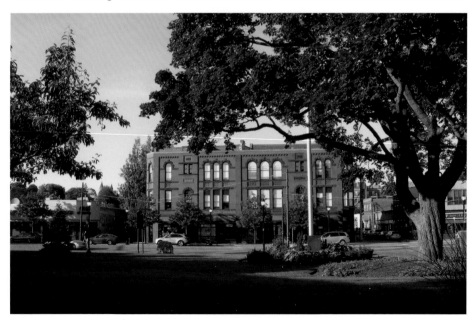

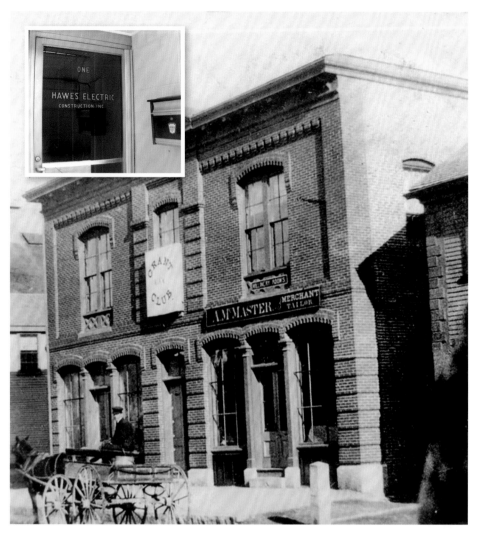

CENTRAL HALL TO HAWES ELECTRIC: Central Hall (shown in the top photograph) was built by postmaster and tailor Archibald McMaster in 1872 on Main Street in Merchant's Row. The building was demolished in 1913 to expand the Otis Building. The Grant Club (Ulysses Grant campaign headquarters) met on the upper floor of Central Hall. The Grant Club sign displayed "G & C" for Grant & Colfax. Lester Legrand Bond, a founder of the Republican party, was the club's first president. The McMaster's tailor shop was on the first floor. Today, Hawes Electric is the only storefront in Merchant's Row, which is now the alley in between the CVS and Uniforms for America. Hawes Electric Construction, Inc. has been lighting up Watertown since 1918 and billed themselves as "Electragists." Hawes Electric was originally established by Otis A. Hawes at 3 Main Street. Otis's son Donald O. Hawes became the next owner, and now his son Donald M. Hawes is the third generation of owners. In the early 1900s, they sold and serviced everything from Radiola radios to Thor washing machines.

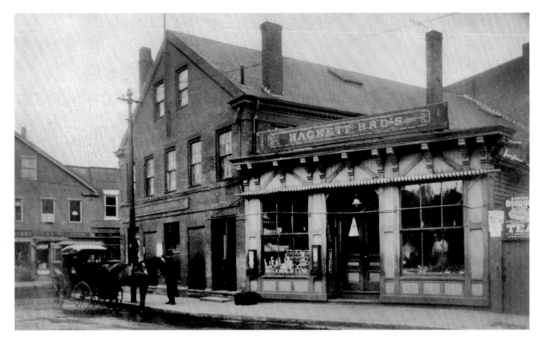

HACKETT BROTHERS TO ALL DENTAL CENTER AND UNIFORMS FOR AMERICA: A grocery established in 1872 by L. A. Shaw and purchased by Francis and Thomas Hackett in 1881, Hackett Brothers sold meat (including pig's feet, Belmont sausages, and Frankfort smoked sausages), fruit, and vegetables. The store was first located at 7 Galen Street (as shown above, the Garfield Block section of Watertown Square that no longer exists) and moved to 25 Main Street in 1905, and then to 21 Main Street in 1921. The Allen's Watertown and Boston Railroad Express would pick up packages left at Hackett Brothers for transport. The bottom image shows 25 Main Street, the current site of Uniforms for America, and 21 Main Street, the home of All Dental Center and its intriguing Zoom! sign.

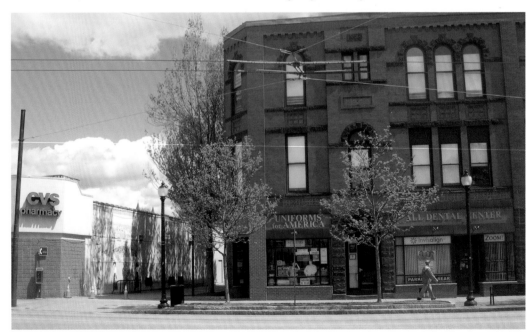

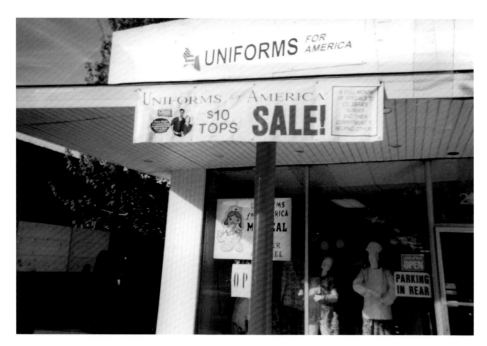

UNIFORMS FOR AMERICA, 1998 AND 2017: The top photograph shows Uniforms for America when it first opened in 1998, and displayed a sign advertising uniforms for "$10 Tops." The bright red pole in front of the store has been removed, but the storefront still advertises great sales. While the store only sells clothing for humans, about a year after the store first opened, owner David Strati was surprised to see a baby duck wander into the store. Mama Duck soon followed, and made a quacking ruckus, trying to scare away anyone who tried to come near her baby. Luckily, David was able to gently place Baby Duck safely back outside.

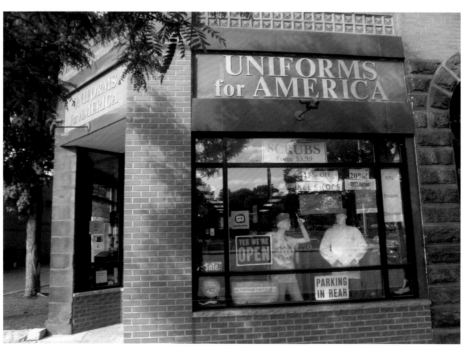

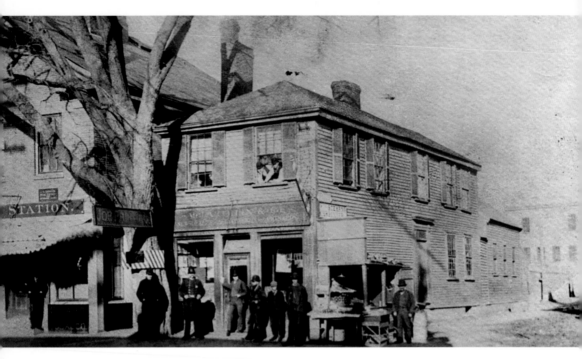

MCLAUTHLIN'S BOOKSTORE TO CVS: Charles C. and Mary McLauthlin's bookstore in the Stearns Building at 27 Main Street sold books, newspapers, stationery, printing, and "fancy goods" in the 1800s, began a circulating library, and served as agents for Metropolitan Laundry. Joseph F. Torre's fruit stand is shown in this photograph from the 1800s outside the bookstore, and there is a street car station to the left. The store moved to 37-39 Main Street, opposite the post office, and was also listed at 87 Main Street. Now 27 Main Street is a site for CVS pharmacy, which opened at the former Woolworth's location at 27 Main Street in 1987.

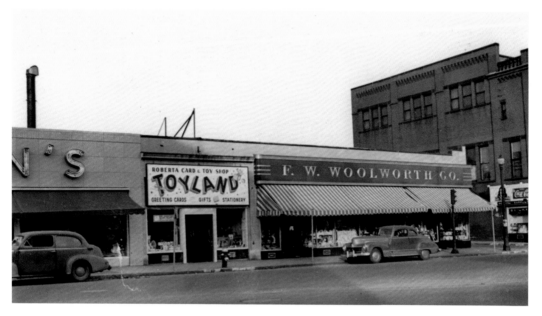

TOYLAND AND WOOLWORTH'S TO CVS: Roberta Card & Toy Shop was affectionately known as Toyland, and sold toys, greeting cards, and stationery. The F. W. Watertown Woolworth Co. Five-and-Dime opened in 1927 at 31-33 Main Street at a site that was formerly the West End Street Railway Company Car Station, Boston Elevated Station, Fred C. Howard's Fruit, Vegetables and Cigars (later named Howard Brother's Car Station and Quick Lunch), and the Watertown Post Office. Woolworth's sported a popular soda fountain and a portrait studio. They also sold penny candy such as Necco Squirrel Nut Zippers (kids just called them Squirrels), Red Hots, and Buttons. Still popular until it was replaced by CVS in 1987, shoppers remember a floor in Woolworth's that was so old that it rippled under their feet. One of Amy Hughes' most vivid memories of living in Watertown was the live turkeys displayed in Woolworth's window before Thanksgiving during the 1950s. Although the numbers 31 and 33 Main Street are not in use anymore, CVS uses the address 27 Main Street.

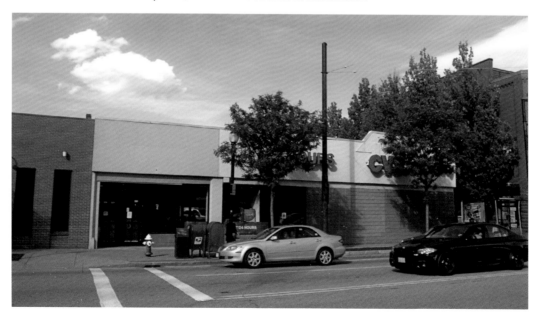

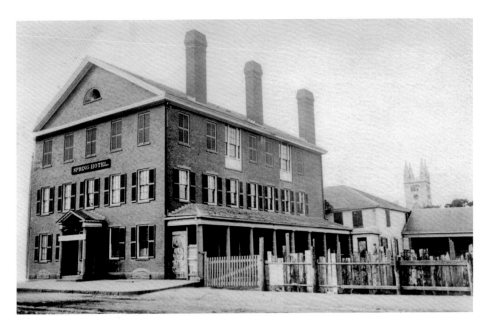

SPRING HOTEL TO STELLINA: The Spring Hotel in the Dana Block was built by Luke Robinson in 1822. But the hotel site was a Watertown Square landmark since the early 1700s—Learned's Tavern was a previous establishment on the property. Spring Hotel guests could frequent W. F. Doherty's Domestic Bakery downstairs and sample home-made candy, or stop by Black the Druggist's store onsite and purchase Cosmo Buttermilk Soap. The Watertown Express carried goods from Watertown to Boston from the hotel site. The town bid farewell to the Spring Hotel in 1883 due to a temperance organization called the Massachusetts Law and Order League, although residents continued to live there even after it was boarded up. There is currently no building at 45 Main Street; the closest address is Stellina at 47 Main Street, who opened there in 1990. The restaurant is named after a young princess who created a beautiful palace out of nothing in a book by Italo Calvino. Bob Manzelli, who has lived in Watertown for over seventy years, especially enjoys Stellina's homemade strangozzi pasta.

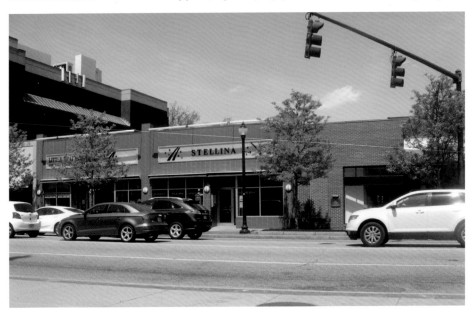

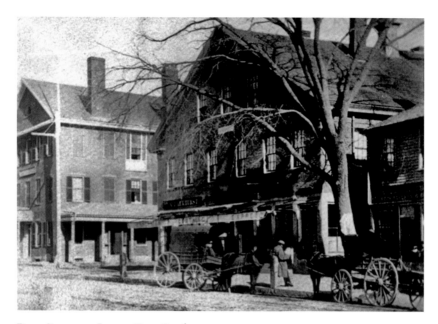

DANA BLOCK TO LITTLE THAI CAFÉ: Grocer Benjamin Dana, member of the Pequossette Lodge of Free Masons, built the Dana Block. The Lafayette Lodge of the Freemasons met on the second floor in the Odd Fellows' Hall on "Thursday evening, on or after the full moon in each month, July and August excepted." Other organizations met at the Dana Block too, including the Relief Fire Association and the Watertown Literary Institution (who met at Institute Hall, of course). Dana Block has been home to many fine institutions throughout the centuries, including the Boston and Watertown Clothing House (which sold "Gents" Fine Furnishings), William F. Doherty Catering, Black the Druggist, the Splendid Cafeteria (established in 1920 and known as "The Last Word in Restaurants"), The Bell Shop for Ladies Clothing, and Watertown Radio Co. The top photograph shows Dana Block in 1869, while the bottom photograph shows a popular, contemporary Asian fusion restaurant now at this location, Little Thai Café, which offers Thai cuisine, of course, and also Chinese, Japanese, and Indian menu selections.

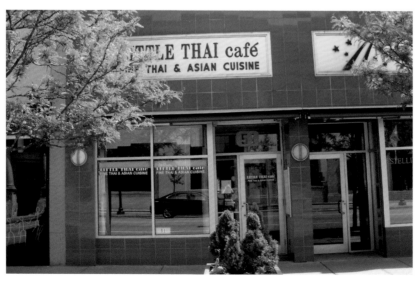

NOURSE AND BARNARD STORE TO NOT YOUR AVERAGE JOES: Joel Barnard's Nourse and Barnard Store sold dry goods, glass, crockery, fancy goods, trimmings, Bon Ton hoop skirts, and kid gloves in the 1800s. Mr. Barnard was also an agent for fire insurance. The store stood to the right of the first Town Hall and didn't have a street number in any of the town listings, but the location puts it where Not Your Average Joe's is today at 55 Main Street. Grants Department Store and later Lefkowitz Furniture sold items there before the restaurant. The Watertown restaurant opened in 1998 and has an impressive array of about 600 recipes and puts forth a new menu about every two months, but wouldn't you know it, one of the customer favorites is the "Joe Schmo" Pizza! The Not Your Average Joe's restaurant gives back to Watertown by donating a portion of their proceeds to a local "cause of the month."

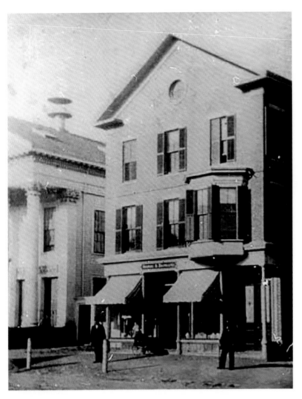

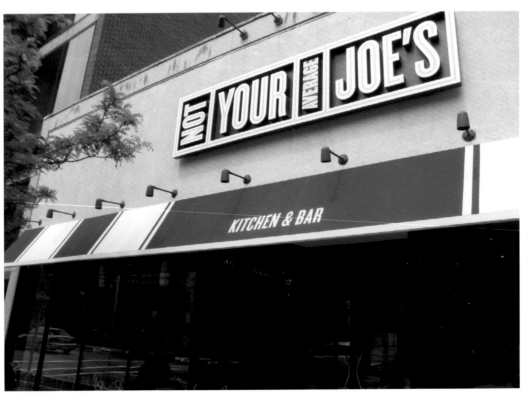

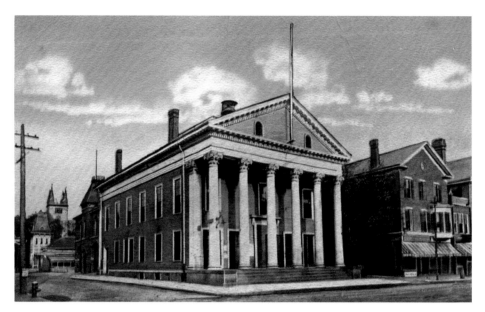

CITY HALL TO ADMINISTRATION BUILDING: The first Town Hall (shown above) was built in 1846 at Main Street and Church Street at what is now the site of the Armenian Library and Museum. The building was also called City Hall and Town House, and had striking Corinthian fluted columns capped with carved acanthus leaves where pigeons perched. The Greek Revival-style Town Hall sported a colonnaded porch and town offices, meeting rooms, stores, the library, and the town jail. The firehouse, engine house, and train station were situated behind the building. The present Town Hall and Administration Building, shown below in Daderot's photograph, located at 149 Main Street, was designed by R. Clipston Sturgis and built by the Works Progress Administration in 1932. The stately building, which is considered a historic property by the Massachusetts Historical Commission, now houses a variety of town offices, including conservation and preservation, community development and planning, the health department, and many others.

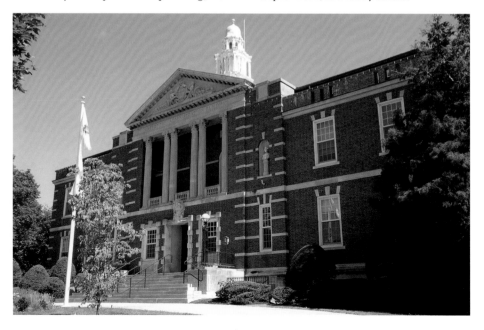

TOWN HALL TO ARMENIAN LIBRARY: The original Town Hall underwent expansion, and in 1866, a theatre was added. Entertainments were many, including child whistler Miss Jennie Perkins and General Tom Thumb, and the Mount Auburn Total Abstinence Society dance and party. Before they had their own church, the Methodist congregation held services at the Town Hall, and the YMCA and Red Cross had meetings there. The original Town Hall site was also home to Coolidge Bank and Trust during the 1970s-1990s. The Armenian Library and Museum (shown below in this photograph by Marilynne Roach) was established at the site of the former Town Hall site at 65 Main Street in 1971. Before that, the library operated from a church parish house in Belmont, MA. Architect Ben Thompson spared no details, designing waffle ceilings and modern brick and glass facades. Today, the museum's collections hold over 20,000 artifacts and the library houses over 27,000 titles. A very special guest at the museum was Armenian President Serzh Sargsyan, who visited in 2016.

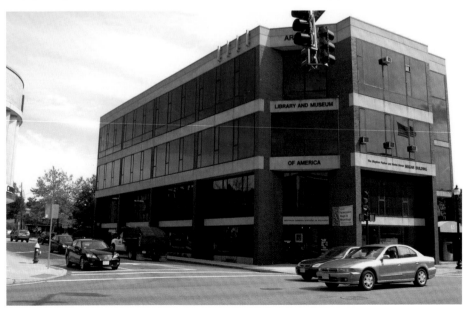

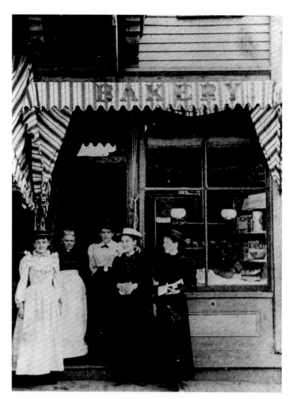

HARRISON'S BAKERY TO ARMENIAN LIBRARY: In the early 1900s, Harrison's Bakery was a sweet spot on the corner of 61 Main and Church Street. The top photo shows the bakery in 1900, with proprietress Mary E. Harrison in the white dress at the far left. Everything was still sweet in the mid-century 1900s when the building was used for the Tots and Teens Specialty Shop. 61 Main Street is no longer a building number—the bakery once stood between what is now the Not Your Average Joe's restaurant at 55 Main Street and the Armenian Library and Museum at 65 Main Street. The 2017 photograph below shows a sign for the library in the approximate location of the bakery displaying images from the museum's wonderful tapestry and Yousuf Karsh portrait collections.

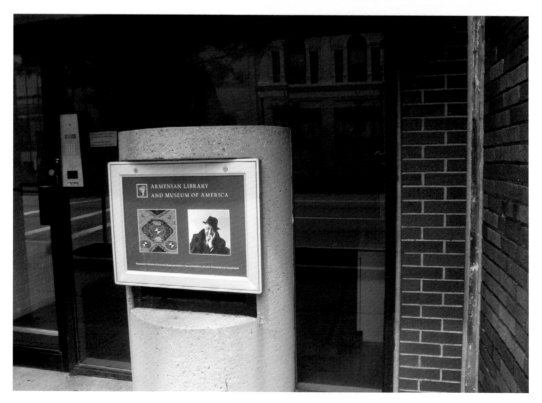

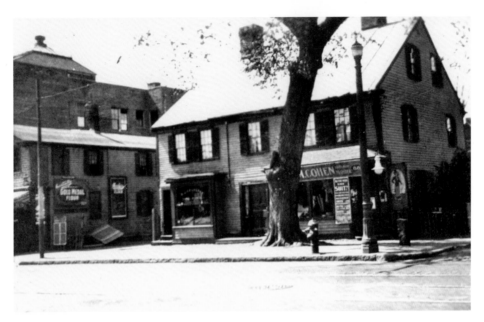

COHEN'S MEN'S FURNISHINGS TO COCA COLA SIGN: In the early 1900s, Morris Cohen owned a tailor shop and later a haberdashery on the corner of Cross Street and Main Street, at 88 Main Street. Mr. Cohen bought the store from tailor Turkey Moran. Francis Rose Cohen took over the shop in the 1930s, and later the property was used for Eddie's Beauty Shop. Today, 88 Main Street is a parking lot next to Jack's Smoke Shop with an iconic Coca Cola sign painted on the side of the apartments above the store, reminiscent of a sign for the "Delicious and Refreshing" beverage in Banker's Row back in the horse-and-buggy days. Jack's Smoke Shop is one of the few remaining stores where shoppers may smoke, and even provides chairs for that purpose. The building also houses Watertown Main Street Florist, where Rubi and Joe Galui's array of lovely flowers grace many local businesses. The previous florist owner, Dave Greenberg, was famous for his website MarryDave.com, where he pledged to pay $1,000 to anyone who introduced him to his bride-to-be.

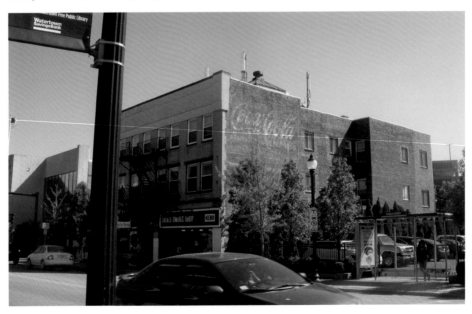

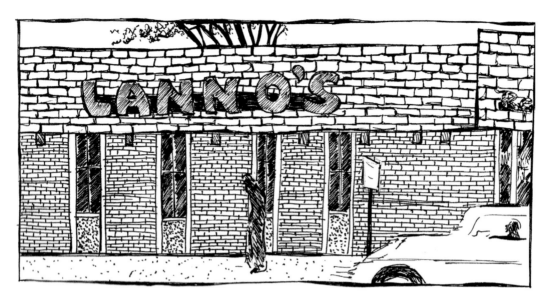

LANNO'S TO PARKING LOT: 86 Main Street was once the Watertown Sea Grill, which opened in 1940 by Cesidio P. Lanno. But most Watertown residents remember it as Lanno's Restaurant, where half the town showed up. Lanno's was well known for their casual family atmosphere and late-night hours. The restaurant served home-style Italian food in Watertown Square from 1965 through 1998. Many generations of the Lanno family worked there, including Cesidio's granddaughter, Andrea, who was hostess, and her grandmother, Millie Laezza, who prepared homemade salads and desserts. Cesidio's son, Joseph P. Lanno, had been studying to be an accountant, but when his father died and left him the restaurant in his will, took over ownership. A patron remembered Lanno's beautiful brass coffee machine from the olden days. It was "the place" to meet. Watertown Mall president Pat Stenson exclaimed, "You had to have come to Lanno's at some point for something!" The Rotary Club and many other groups large and small met there. Now the site is a parking lot.

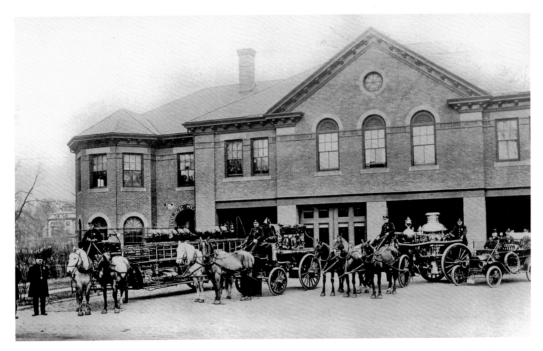

FIRE STATION: The earliest Watertown Fire Station was built in 1846 behind the Old Town Hall. In the 1880s, the fire department operated with one steam fire engine, one four-wheel hose carriage, one book and ladder carriage, one fuel wagon, one hose pung, four two-wheel hose carriages, and a fire alarm telegraph system. The Fire Station at 99 Main Street was designed by Alberto F. Hayneson and built in 1906 on the grounds of the former St. John's Methodist Church and Young Man's Catholic Association. The Watertown Fire Department of today contains fire trucks with 1,250 gallons-per-minute pumpers and a Boston Whaler Rescue Boat, and they respond to approximately 4,500 calls for assistance annually.

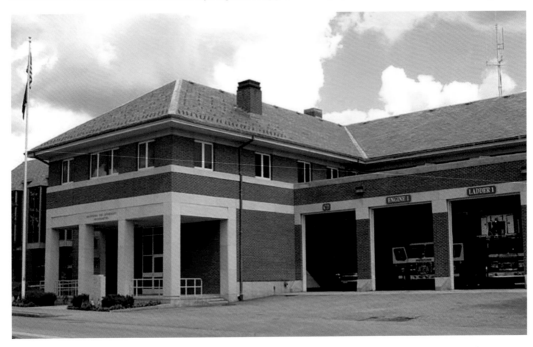

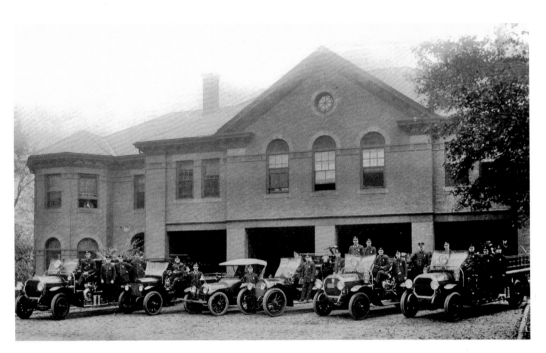

FIRE STATION: The early fire department shared space with the police department, employed four permanent firemen, and a bell alarm tolled fire locations. The alarm also rang to signal the town curfew every night at 8:45 PM. Eight sprinklers drawn by fire station horses laid street dust on Main Street when it was a dirt road. The First Parish Church near the first Town Hall had the official "town clock," and a town fireman was paid to tend it. The current building at 99 Main Street opened in 1991. Though about a hundred years apart, the two photographs show the fire department outfitted in full regalia. The bottom photograph from 2015 shows members of the fire department and the Marine Corps League commemorating a Korean War veteran.

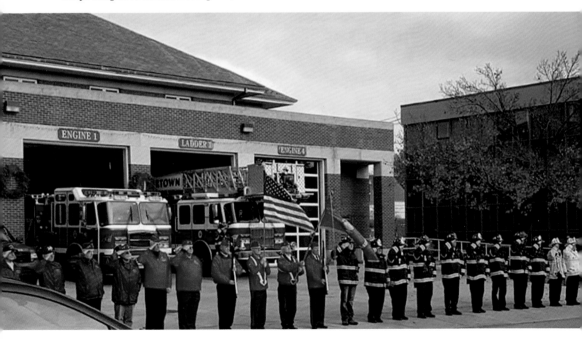

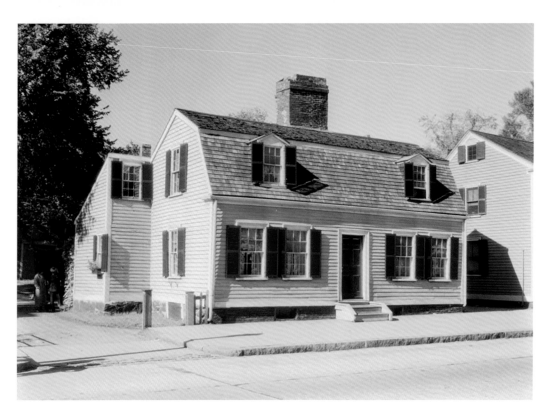

DANIEL CALDWELL HOUSE TO
POST OFFICE: The Daniel Caldwell House
was built in 1742. The clapboard and shingle
house remained a private home during the
early part of the twentieth century and was
demolished in 1942. The earliest Watertown
post office was established on Galen Street
near the bridge. Postal rates used to be
five-and-a-half pence to mail a letter 60
miles. In 1775, Congress established a
two-story post office on Main Street across
from Merchant's Row, to serve routes to
Philadelphia and New York. The Eight H. P.
Association met in the post office building
for literary and social improvement. At one
time, the post office operated out of Baptist
Walk. Archibald McMaster, who founded the
McMaster Block, was the post-master. Mail
arrived and left at 9 AM, noon, and 5 PM. A
new post office with 200 boxes was erected
in 1897 at the corner of Main Street and
Mount Auburn Street, and the postal service
also operated from 44-46 Mount Auburn
Street during the early 1900s. The post office
moved to 126-126a Main Street in 1942.

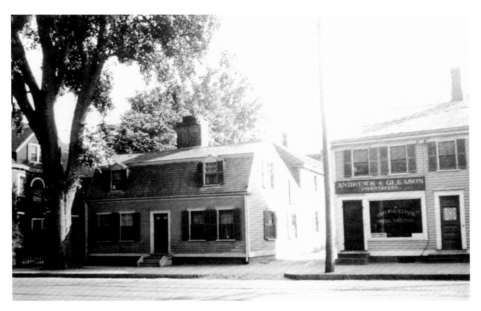

ANDREWS AND GLEASON TO WINNICK BUILDING: William S. Andrews and Patrick D. Gleason operated Andrews & Gleason Funeral Directors at 132 Main Street in the 1910s. They also sold coffins and caskets and performed embalming services. 132 Main Street was an address for the Winnick Building, built in 1785 and currently owned by attorney Stephen M. Winnick of Winnick & Sullivan LLP. The first owner of the house was William Leathe, who lived there and ran his blacksmithing business from the building. The Winnick Building currently uses the address 134 Main Street, as attorney Winnick, founder of the Watertown Economic Development Corporation and responsible for the landmark Massachusetts decision on right to recover from a "wrongful birth" from negligent genetic counselling, was given a choice of 132 or 134 when he bought the building. The shed in the top photograph shows the 1800s "spite barn" (a built structure to block neighbor's views) in 1986, before it was renovated to become a parking area for the building's tenants. The Winnick Building is considered a historic property by the Massachusetts Historical Commission.

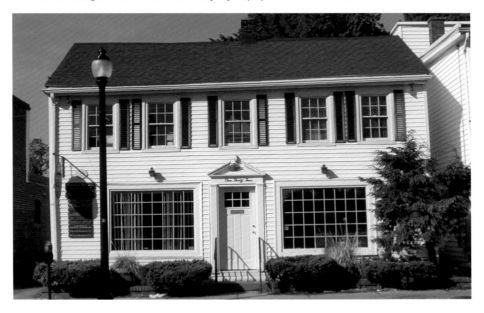

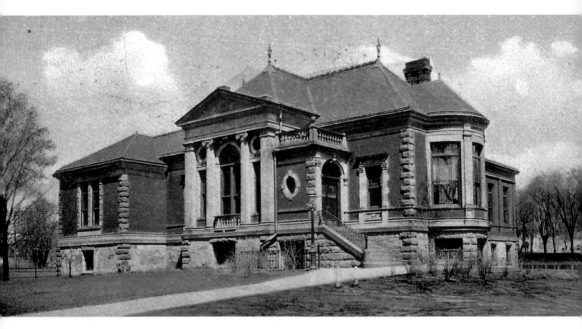

WATERTOWN FREE PUBLIC LIBRARY, 1907 & 1955: The Watertown government and library trustees began planning a freestanding 24 x 62-foot square library in the 1860s. The first library was opened in Watertown Square in 1869, and was housed in the Town Hall on the corner of Main and Church Streets. It was only open on Wednesdays and Saturdays. Solon Whitney was the first librarian. The present Watertown Free Public Library at 123 Main Street (shown in the illustration above) opened in 1884. The French Renaissance-style building sported red sandstone trim and Roxbury rubblestone. An extension was built in 1894 in the rear of the building with glass floors to bring in more light and circular glass windows. The annual report of 1895 stated that, "The lower reading-room is for the use of all persons who observe the common rules of good behavior." There used to be a dirt lot in back of the library for parking before the current parking lot was built. A modern addition to the library was erected in 1951.

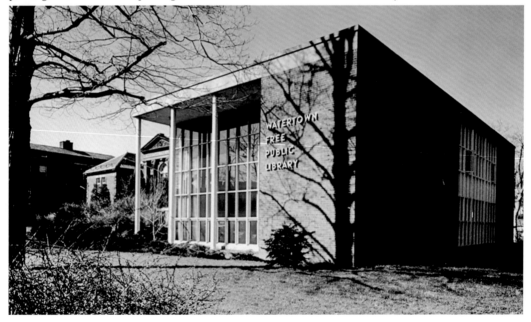

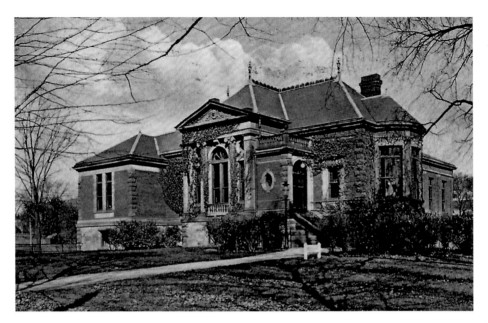

WATERTOWN FREE PUBLIC LIBRARY, 1910S AND NOW: 2006 saw a major renovation and expansion through the vision of architect Lerner, Ladd, and Bartel, with new construction doubling the square footage of the library. The white Norway maple tree in front of the library survived through the construction, and the original circular staircase and fireplace from the very first library building still remains. One of the newest innovations is a bright yellow bicycle repair station installed in 2015 outside the front of the library, near the bicycle rack. The library is considered a historic property by the Massachusetts Historical Commission. A library staff member from the 1960s recalled stamping date-due cards, and the cardboard library cards that she hand-wrote borrowers' names on. At that time, Nancy Drew mysteries were all the rage. Today's Watertown Free Public Library visitors can select from an expansive array of books, DVDs and Blu-rays, CDs, magazines, video games, e-books, audiobooks, e-readers, and other equipment.

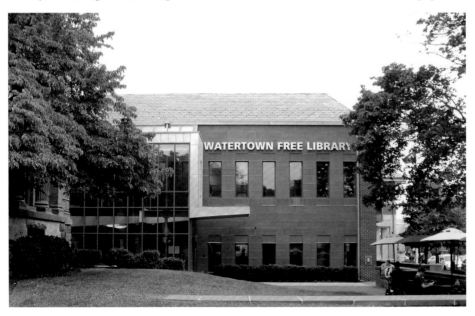

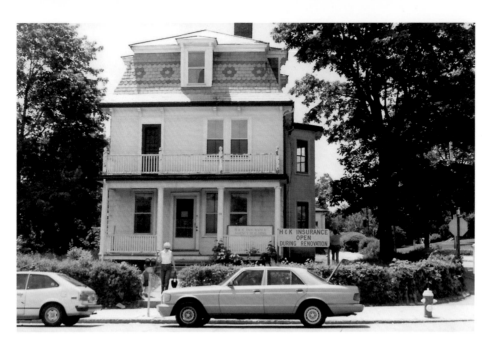

H & K BUILDING, 1981 AND 2017: John F. Kilcoyne and his wife Herlihy founded H & K Insurance in 1961 in Newton, and moved to Watertown in 1963. The insurance agency has operated at various addresses on Main Street, Mount Auburn Street and Galen Street, but found its home in 1981 at 182 Main Street across from Saltonstall Park. The top photograph shows Herlihy and the Kilcoyne's son Brendon (who is now an owner operator with their other children Brian and Darilyn) in front of the fancifully decorated two-story home. John wanted to build a new structure with architecture that worked well with the neighboring St. Patrick's Church. H & K's specially designed arched windows were among the earliest solar windows in Massachusetts. The Kilcoynes continued innovations to win an award from the Massachusetts Insurance Association in 1990 as the most computerized agency in Massachusetts, and to help introduce no-fault insurance to the state. Dr. Jason Mavor began his chiropractic service (which also offers massage) in the building in 2011.

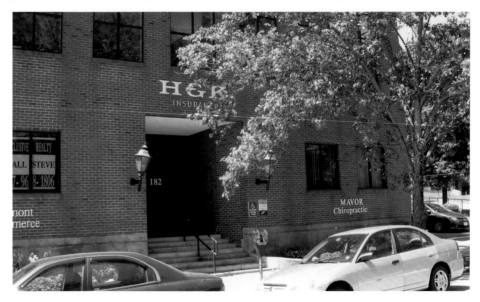

SAINT PATRICK'S CHURCH: St. Patrick's Church had roots in 1837 at the site of a former academy building. In 1847, the congregation bought a Methodist church and moved it to Church Hill. The cornerstone was laid at the present Saint Patrick Church at 212 Main Street in 1901. The impressive Gothic structure with windows of European glass, stained glass, and American opalescent glass was designed by architect E. G. Bullard and accommodates 1,500 people. When the new church opened, the old Church Hill Street building became a parish hall. In 1909, a cast bell was installed in the new church, which still rings today. In 1997, the old church at the top of Church Hill was torn down. The church is considered a historic property by the Massachusetts Historical Commission.

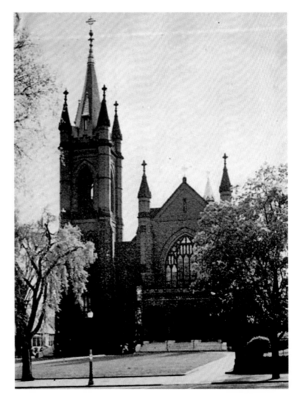

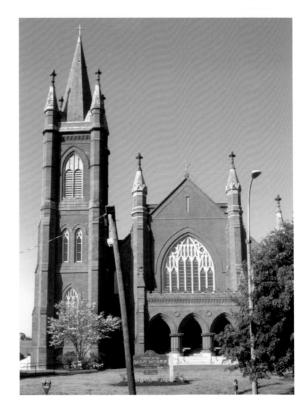

CHARLES RIVER ROAD: Charles River Road is under the jurisdiction of the Department of Conservation and Recreation and has remained an unperturbed passage along the Charles River. Looking at the photograph from the early twentieth century and the one taken recently by David J. Russo, the dirt road has been replaced by a paved one, a metal fence has replaced the rustic wood one, and some homes have been built as the trees grew larger. That's not to say that there are no surprises—the Department of Public Works recently discovered a forgotten stone pipe culvert spanning from Charles River Road to Mount Auburn Street about 18 feet under the roadway. If you want to step off the beaten path and away from the traffic, try the Charles River Road route for Watertown's River Walk and you'll see flowers as lovely as the ones centuries ago. The Massachusetts Department of Transportation recently started exploring the possibility of relocating Charles River Road to improve Watertown Square traffic conditions.

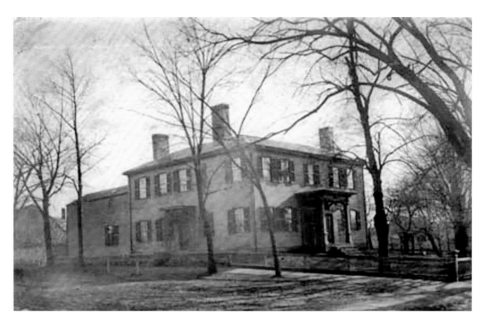

FRANCIS HOUSE TO JOSEPH A. MACDONALD FUNERAL HOME: The first pastor of the Unitarian Church was Convers Francis, who lived at the Francis House at 6 Riverside Street (once Morse Mansion, then the Joseph A. MacDonald Funeral Home and now the MacDonald Academy of Martial Arts). A scholar, biographer, and historian, Convers Francis captured much of Watertown's earliest history in his books that included *An Historical Sketch Of Watertown In Massachusetts From the First Settlement Of the Town To the Close Of Its Second Century*. His sister, Lydia Marie Child, (author of *The Frugal Housewife*) wrote the original poem in the Francis House at 6 Riverside Street in 1844 that was made into the well-known song, "Over the river and through the woods, to grandmother's house we go." Ralph Waldo Emerson was also a frequent visitor of Convers Francis. The Francis House is considered a historic house by the state of Massachusetts, and some of the early features, window casings, original stairway, and fireplaces, are still in use.

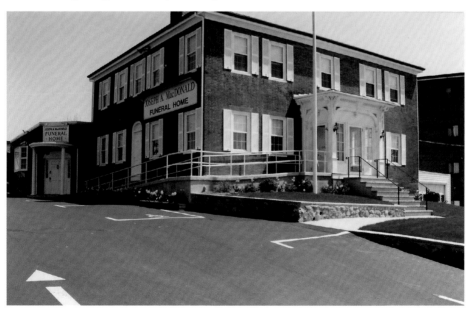

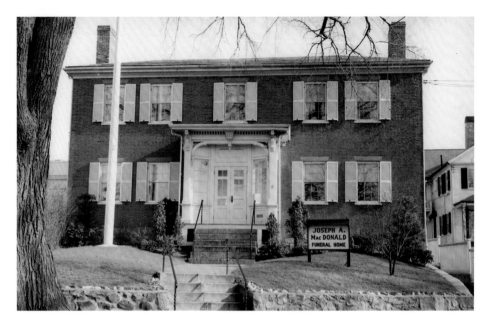

JOSEPH A. MACDONALD FUNERAL HOME TO MACDONALD ACADEMY OF MARTIAL ARTS: Operating one of the first funeral homes in the area, the Donald J. MacDonald family opened their first establishment at 270 Main Street in 1935. In 1945, the Joseph A. MacDonald family (the name was a coincidence, the families were unrelated) opened a funeral home on 6 Riverside Street. There was also a Rockwell Funeral Home on Mount Auburn Street slightly past the Square. In 1996, the three funeral homes merged, and the MacDonald, Rockwell, & MacDonald Funeral Service opened at both the Riverside and Main Street locations. In 2010, the funeral home found its current home in the 270 Main Street location. The former MacDonald Funeral Home at 6 Riverside Street in Watertown Square is now an active karate studio, the MacDonald Academy of Martial Arts. The karate studio had opened in 1993 and moved across the street from 32 Arsenal Street in 2010. It is run by descendants of the Joseph A. MacDonald family.

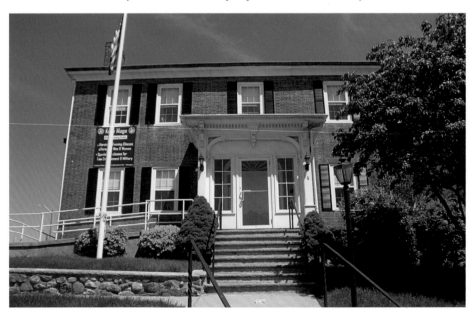

OTIS BROTHERS DRY GOODS
STORE TO MOUNT AUBURN STREET
AND MAIN STREET CORNER:
Otis A. Train had been an employee
of Jesse Wheeler, married Mr.
Wheeler's daughter, and carried
on his dry goods business. Horace
and Ward Otis bought the store in
1866 and moved it to Main Street in
1896. Otis Brothers sold everything,
including oil cloths, "gent's
furnishings," millinery, cloaks,
and corsets. Where the H&R Block
business is now, Tierney's Bakery
once stood in the 1950s and Barrett
Jewelers was fondly remembered
later in the twentieth century.

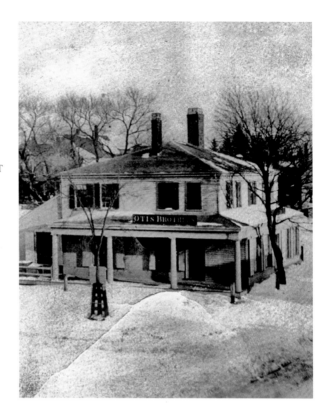

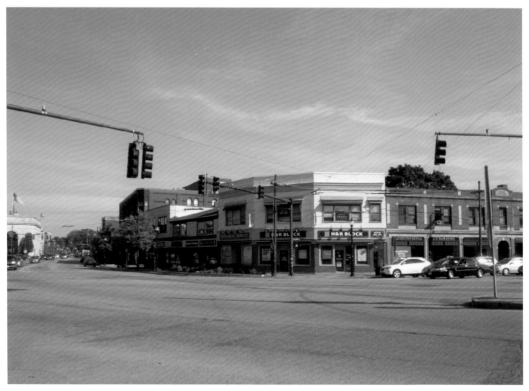

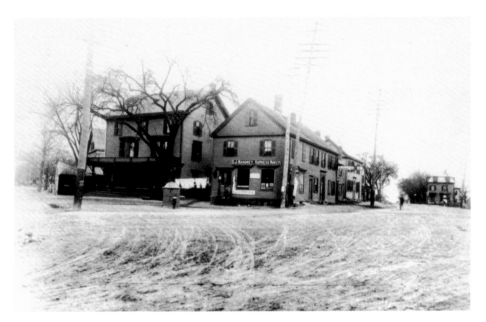

KELLY'S HOTEL AND NORTH BEACON STREET: Kelly's Hotel (first known as the Watertown Hotel) stood at corner of Mount Auburn and Arsenal Streets to the left of D. J. Mahoney's Harness Maker. Before it was Kelly's Hotel, the property was owned by Thomas Patten. The hotel opened in 1864 and was managed by Patrick (PJ) and Hannah Kelly. It was shut down in 1883 by the Massachusetts Law and Order League temperance organization and sold to Jenny's Gas. PJ and Hannah's son Thomas Kelly opened Kelly Provisioners at 3 Mount Auburn Street and used a wagon for its deliveries of butter, eggs, and potatoes. PJ's brother Thomas Kelly was a blacksmith who opened Kelly & Meany Blacksmiths with a family member at Spring Street, and then moved to 28 Arsenal Street. Thomas Kelly also owned Jackson's Blacksmith shop, and was the last remaining blacksmith in town during the 1930s. The dirt roads in the top 1916 photograph were made for horses, while the bottom 1950 photograph shows cars and trucks sharing a busy road and mazelike tracks with trolleys.

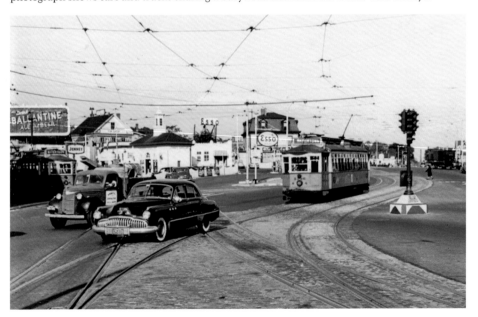

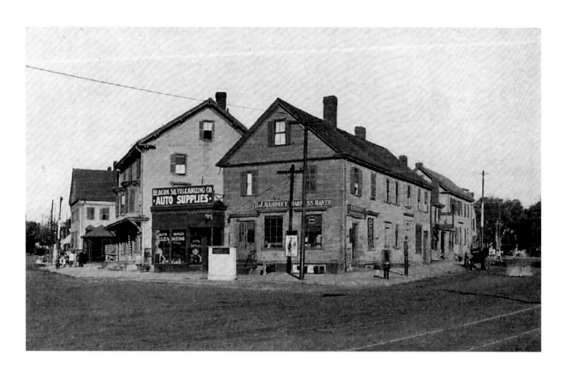

DJ MAHONEY HARNESS
MAKER TO TOWN CLOCK:
DJ Mahoney Harness Maker
stood on the corner of Mount
Auburn and Arsenal Streets with
the address of 1 Arsenal Street.
Daniel J. Mahoney provided
harness repairs and supplies in
the late 1800s and early 1900s.
The top photograph signals
both the old and the new with
an auto supply store right next
to a harness shop. Nowadays
when you visit the corner
businesses listed at 1 Mount
Auburn Street, you can get your
hair cut, colored, and styled
at Supercuts, and enjoy sub &
club sandwiches with signature
potato chips at Jimmy John's
Gourmet Sandwiches. A vintage-
style clock reminds the town of
bygone days.

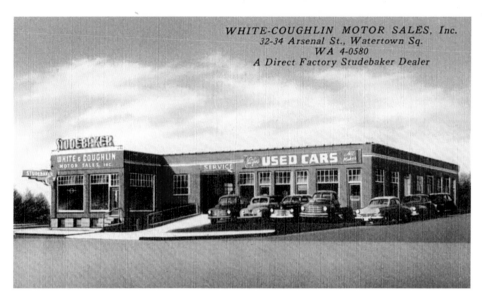

WHITE-COUGHLIN MOTOR SALES, Inc.
32-34 Arsenal St., Watertown Sq.
WA 4-0580
A Direct Factory Studebaker Dealer

WHITE-COUGHLIN MOTOR SALES TO O'REILLY'S AUTO BODY: White-Coughlin Motor Sales at 32-34 Arsenal Street was once Watertown's direct factory Studebaker dealer. You can't buy a car at 32-34 Arsenal Street anymore, but you can get one fixed at O'Reilly's Auto Body. The location has hosted a number of auto-related businesses, including C. E. Batchelder & Co. Inc. (featuring bargains in "REAL GOOD" Used Cars), Bumper and Auto in the 1970s, Quality Foreign Cars from 1978-1900, and Detail Auto Body toward the end of that era. Bernie O'Reilly, Jr., whose father Bernie O'Reilly, Sr. owned O'Reilly's Auto Body in the Nonantum section of Newton, started looking for a place to move the business in 1990 and "Watertown Square was the one I kept coming back to." He opened the shop in Watertown in 1993, and has never done any advertising, since all his customers find out by word of mouth. The shop is licensed to service thirty-four cars at once, and many of the staff have stayed on for about thirty years.

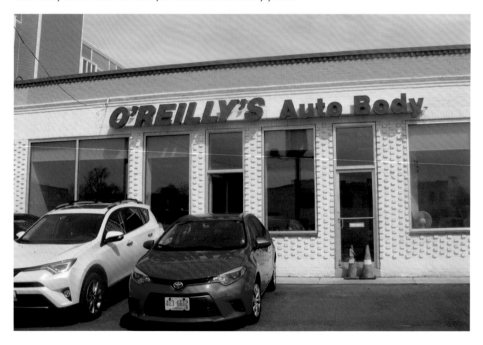

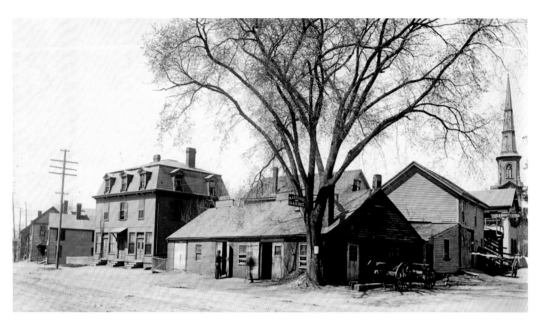

ARSENAL STREET, 1910 AND 2017: Arsenal Street was opened in 1824 by the West Boston Bridge Corporation, and was known as the Watertown Turnpike. It became a public highway in 1859 and was widened in 1893, but was still a dirt road in the early 1900s. Antipas Jackson built a blacksmith shop on Arsenal Street near Taylor Street and the Baptist Church. Jackson also provided carriage making and painting services. His shop supplied irons for a schoolhouse fence and repair of the town fire hooks. The top photograph shows Antipas Jackson's Blacksmith Shop in 1910. Nowadays, you won't be able to get a horse-drawn carriage fixed, but you can certainly get your car fixed at the same location at O'Reilly & Son Auto Body on 32 Arsenal Street. The Old Baptist Church is no longer in Watertown Square. O'Reilly's expanded when the MacDonald Academy of Marshall Arts moved across the street to 6 Riverside Place and the new 24 Arsenal Street Condominiums were built in 2011 at the site of a former home located on the property and the fondly remembered Casey's restaurant.

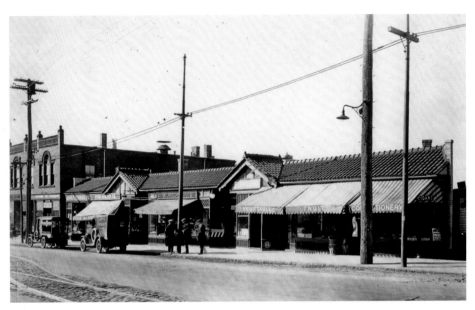

MOUNT AUBURN STREET, 1920 AND 2017: Mount Auburn Street was also called Mill of Cambridge Road, or simply, "The Road to the Mill." Where Main Street and Mount Auburn Street met, the convergence was at one time called Beacon Square. Mount Auburn Street was widened in 1895. Some of the earlier Mount Auburn Street businesses included Fletcher's Hardware Store, Lyman Meat Market, Vahey's Drug Store, Snow's Fish Market, Associated Tire Corporation, Great Atlantic & Pacific Tea Company, Mount Auburn Green Bag, *Watertown Sun* newspaper, Kelly the Florist, Kaleidoscope Books, and Remembering Floral Design. In the bottom photo you can see many of Mount Auburn Street's Watertown Square stores of today, including Watertown Dental, JC Hair Studio, Freestyle Hair Studio, Diamond Nails (a silky milk manicure sounds divine), Tiki In Restaurant (a longtime destination in the Square with an open kitchen and 25¢ carnival games like the Star Gazer Grip Tester), Thomson Safari, Watertown Center for the Healing Arts, Oriental Foot Reflexology, The Meat Spot, Watertown Sportswear, and Michael Computer Repair and Tech Services.

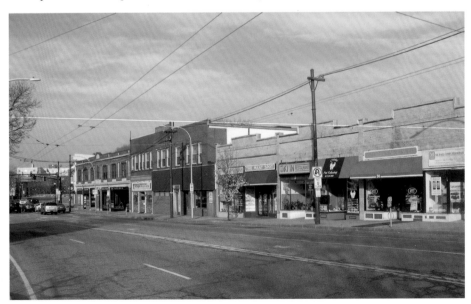

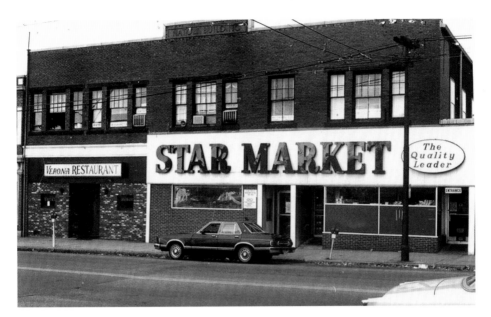

STAR MARKET AND VERONA RESTAURANT TO IXTAPA MEXICAN CANTINA AND CENTER FOR HEALING ARTS: Star Market was purchased by Sarkis Mugardichian of the Mugar family in 1916. The site had been an MTA car barn. With entrances on Mount Auburn Street and Spring Street and much-trodden wooden floors, the market sold everything from Christmas fowls to sunshine biscuits and provided free delivery. Verona Restaurant (which was renamed The New Verona) was its neighbor for many years and the Barbara Seahorse Dance Studio was on the floor above it. Ixtapa Mexican Grill & Cantina opened in 2015 at the site of the former Verona restaurant. Ixtapa manager Ramone Zarazua says that he and his staff "love being in Watertown Square." Their authentic Mexican food draws crowds, and events like their Cinco de Mayo celebration deliver on their promise to make people feel like "part of the family." Mount Auburn Street visitors can also relax and rejuvenate at the Watertown Center for the Healing Arts, with services including relational somatic therapy and Feldenkrais.

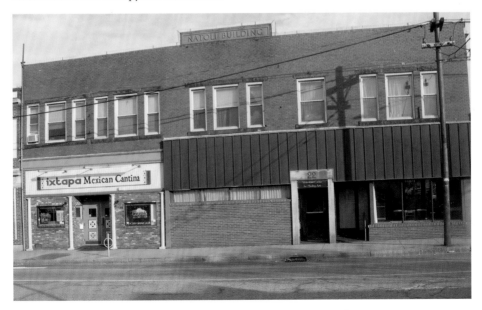

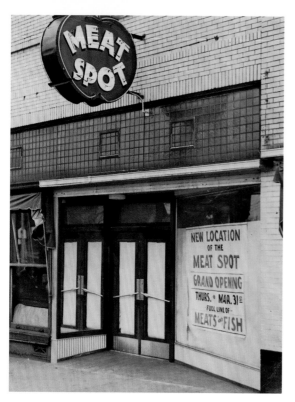

THE MEAT SPOT: Originally where Star Market had its first store, The Meat Spot was founded in 1948 by Nello and his son, Henry Cerqua, who performed the actual meat-cutting in the store's basement. In the 1970s, The Meat Spot was used for a commercial about financial planning. The store was purchased by present owners Dikran and Karen Ucuz in 1991. The Meat Spot has added a modern awning, but still does a lot the old-fashioned way, such as tying their roasts with butcher twine.

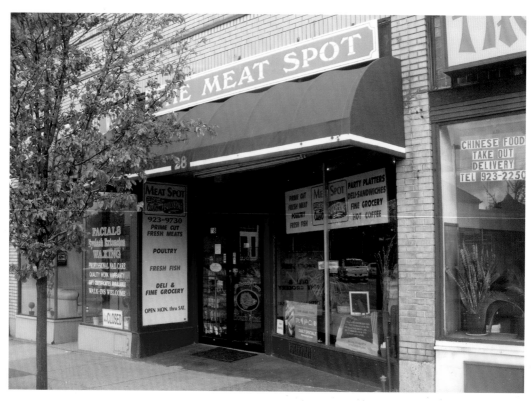

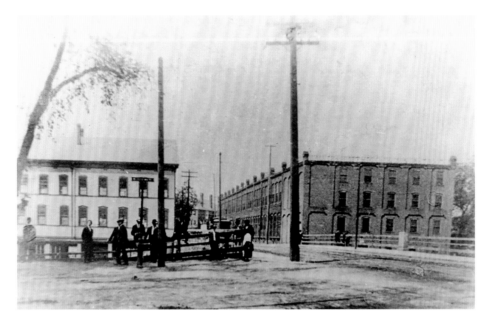

WALKER AND PRATT TO GALEN STREET BRIDGE: Established in 1855, the Walker Pratt Foundry manufactured and sold all manners of stoves, furnaces, tin-roofing, and even agate ware for the kitchen. Before the foundry was established, the grounds were the site of the Blackman House, the Barrett House, and the Major Pierce House. During the Great Flood of 1886, all but the front wall of the building collapsed. The Walker & Pratt Manufacturing Co. moved its foundry to Galen and Main Streets in 1896 and became Miles Pratt & Co. Children would stand on the sidewalk and peer in the windows every afternoon at 2:00 PM to catch site of the workers transferring burning hot fluid to molds. In the Blackman House days, Benjamin Edes printed the *Boston Gazette and Country Journal*. The press and type had to be carried down the Charles River. While there are no buildings at 12-23 Galen Street today, residents and visitors can catch their first glimpse of the Watertown Square flag as they pass the area where the foundry once was.

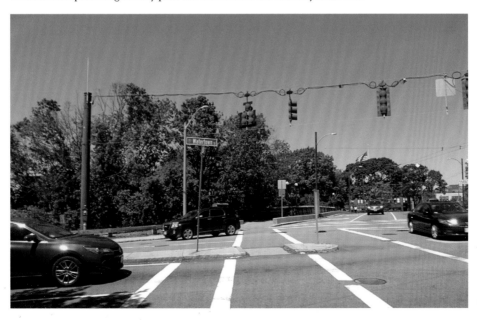

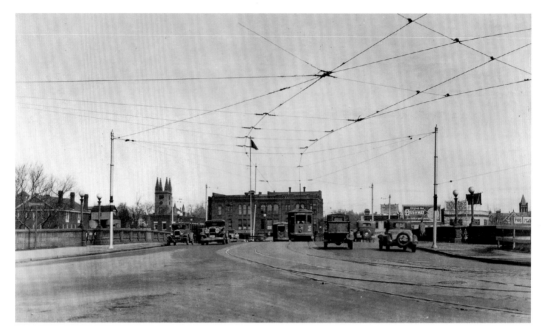

GALEN STREET BRIDGE WITH VIEWS OF SQUARE, 1932 AND 2017: Galen Street, built in 1635-37, was originally called Country Road and then Boston Road in the 1700s. The early Galen Street was longer than today's street; it terminated at Pleasant Street. John P. Shurcliff's 1932 photograph, courtesy of the Massachusetts Department of Conservation and Recreation Archives, shows a time when trolleys shared the same stretch of Galen Street roadway as motor vehicles. The Galen Street Bridge of the 1800s and early 1900s curved slightly to the east. Cars travelling through Galen Street used to cross the bridge and end up where CVS is today. Drivers would need to turn left onto Main Street and then right onto Mount Auburn Street to continue north. Today's drivers and passengers can thank the town's thoughtful planners as they travel north straight through the Square.

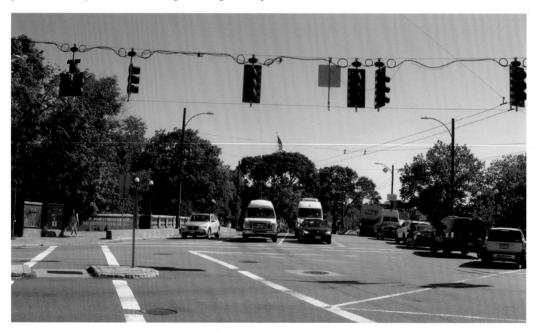

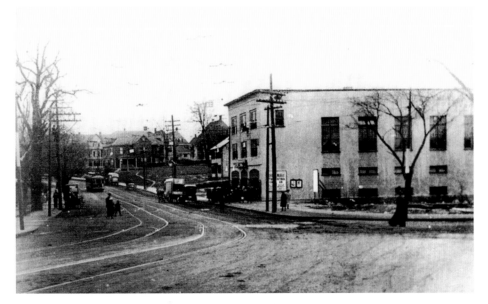

WATERTOWN SQUARE THEATRE TO WATERTOWN SQUARE APARTMENTS: The Galen Street Cinema, constructed in 1900, was called the Strand Theatre, Watertown Strand, Pequosette Hall Movie Theatre, and affectionately, "The Flea." The cream-colored theatre was next to the Galen Spa on the corner of Galen and Watertown Streets. E. M. Howe reopened it in 1929 with "All Talking Pictures." It again reopened as the 640-seat Watertown Square Theatre in 1932. Movies included *Mrs. Wigg's Cabbage Patch* and *The Nights in a Bar Room*. The theatre was used for other events like religious holiday services, and sported an electric piano, bowling alley, and pool room. John Kilcoyne, owner of H & K Insurance, remembers collecting bottles with friends, turning them in for 2-cent deposits, and spending the afternoon at the theatre watching 5-cent films in the 1960s. Toward the end of the theatre's domain, it became an AMC Loews Theatre. Its final name was Pike Productions. Today, the Watertown Square Apartments add a distinctive architectural flair and two new restaurants are planned at the sites of the corner's former convenience store and pizza parlor.

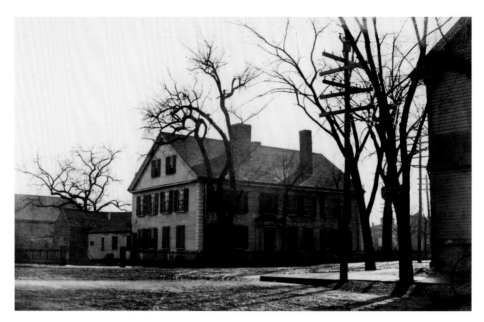

WATERTOWN STREET SIGN TO STELLINA: Stellina was originally opened in 1986 by the Virginia (Ginnie) Curcio and her late husband Frank Curcio. The first Stellina was on Galen Street, on the property formerly owned by the Galen Pub in between Coombs Ford (now the site of Colonial Buick GMC) and the Watertown Yard MBTA car barns. In colonial days, this was the site of the Coolidge Tavern, frequented by our founding fathers. Although the original restaurant was small, it was fondly remembered by many, especially those who had their first date there and are now bringing their children to the current Stellina. The next generation of Curcios, Frank and Ginnie's son, Michael, is now a chef. There are a few items from the original menu that are still on today's, including warm tomato salad and broccocini (small crepes with ricotta and spinach). The top photograph shows a sign with "Watertown St. and West Newton Wellesley Natick" with a hand pointing to the right in the area that would become the first Stellina.

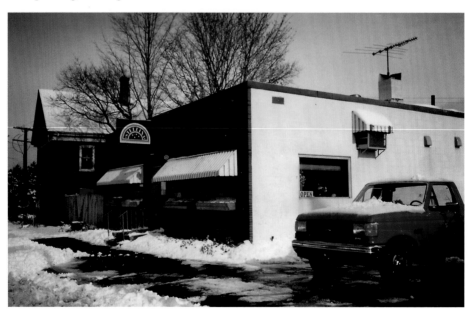

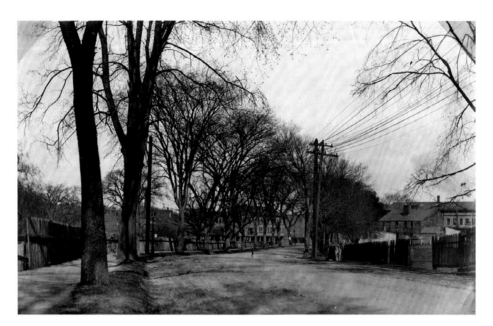

WATERTOWN STREET, 1895 AND 2017: Watertown Street (known as South River Street in earlier days) was laid out soon after the horse cart bridge was constructed in 1719. In 1929, curbing that had been used at the town barn was moved to add curbs to Watertown Street. Early Watertown Square businesses on Watertown Street included Howard Brother's Ice, Emerson and Thompson Manufacturers of Soda Water and Root Beer, Porter Needle Company and Piccolo' Pharmacy (The Rexall Store, "air conditioned for your comfort"). In 1958, Felix Bosshard founded Gaston Andrey Associates (later Watertown Saab-Datson) at 20 Watertown Street to sell and service Saab automobiles. In the top photograph, the Coolidge Tavern and a number of other homes and businesses along the Square are visible on Galen Street after the bend of Watertown Street. The bottom photograph shows the current building at 20 Watertown Street, Watertown Square Apartments, but the lush trees flanking the Charles River take center stage and obscure the view of Watertown Square.

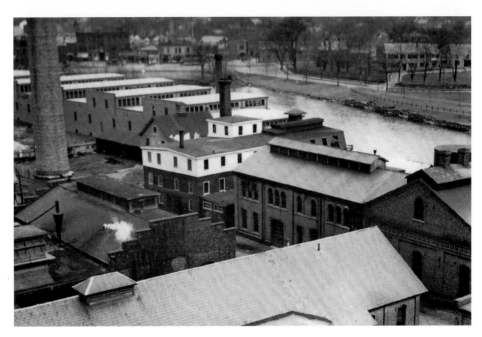

GAS WORKS TO COLONIAL BUICK GMC PARKING LOT: The large Gas Works was built around 1850 near Town Landing and Whitney's Distillery on Water Street. A town directory from 1874 listed its address as Starch Factory Lane. The Newton and Watertown Gas Company, which became the Newton and Watertown Gas Light Company, was incorporated in 1854. In its heyday, the company supplied the town with 100 arc lights per year for street crossings. In 1907-1908, an electric light station, stable, store house, purifier building, valve houses, gas holders, oil tank, retort house, generator house, pipe shop, and coal sheds stood on the property. In preparation of the building of the Watertown Delta in the late 1920s, the old chimney stacks of the gas works were removed. Although there are no businesses listed at 39 Water Street today, the location is now the site of Colonial Buick GMC.

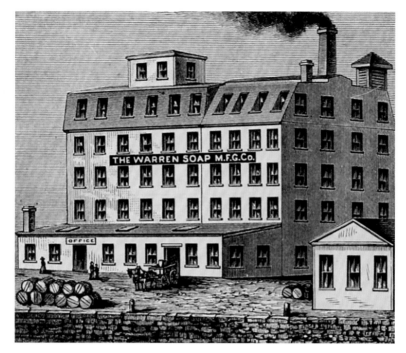

WARREN SOAP TO MBTA PARKING LOT: The Warren Soap Manufacturing Company (also called Warren Soap Works) at 46 Water Street in Watertown Square was established in 1870 and incorporated in 1890. The factory was opened in the same area as the Newton and Watertown Gas Light Company and operated in Watertown through the early 1900s, where they were listed in town records as operating out of 46-48 Galen Street. They advertised as the largest manufacturer of textile soaps and wool scourers in the country, and specialized in decarbonizing soap and cotton softeners. The property was the former site of Sterling Elliot's Bicycle Factory and a hat factory earlier in the 1800s. The top illustration shows the original factory building at 46 Water Street and the bottom photograph shows the area as it is used now, as an MBTA-owned public parking area.

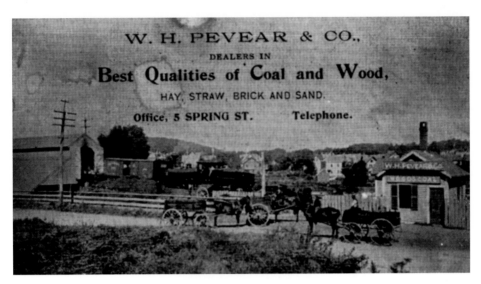

W. H. PEVEAR & CO.,

DEALERS IN

Best Qualities of Coal and Wood,

HAY, STRAW, BRICK AND SAND.

Office, 5 SPRING ST. Telephone.

WATERTOWN COAL ELEVATOR TO MOLANA: W. H. Peaver operated Watertown's coal elevator with offices at 36 Main Street and 5 Spring Street. The elevator carried coal, wood, straw, hay, sand, and brick. 5 Spring Street (the Russell Building) later became the Spring Street Grill, Ward's Restaurant, Mark's Pub, and Union Cafe. Today, one can frequent the Molana Restaurant at 5 Spring Street. Molana, named after thirteenth-century Persian poet and mystic Molana Jalaleddin Rumi, opened in 1999. Co-owners Mohsen Tehrani and Hadi Eghbali fashioned a restaurant that serves as a social center for the Iranian community. With live Iranian vocal and instrumental music and decorative serveware and spices imported from Iran, people come from all over to give and receive help with housing, jobs, and more while they enjoy authentic Persian and Iranian food. A popular menu item is Beef Sultani, which means "fit for a king" and includes skewers of tenderloin steak. Their rice is slow-cooked and takes four to five hours to prepare. The original 1800s brick from the Coal Elevator office still form the restaurant, including an interior wall.

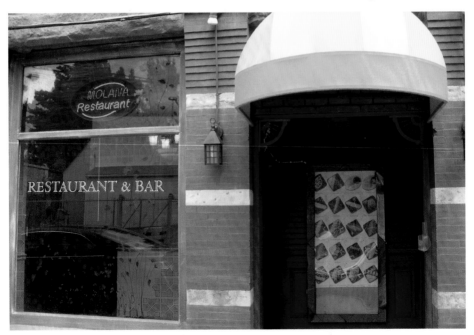

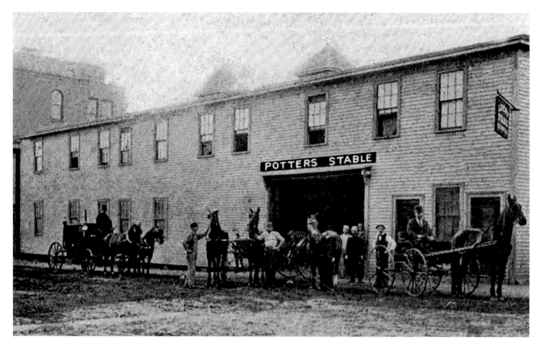

POTTERS STABLES TO EDISON BUILDING: During the early 1900s, Briggs Potter's Livery Stables at 18 Spring Street remained open all night, boarding horses and providing saddle horses, horse clipping, and hack livery services. The stable owned about fifty horses and was managed by Mr. MacDonald of Riverside Street. Potters Stables also offered "automobiles to let." The site was acquired by Boston Edison in 1922 and now houses the Edison Building, which is operated by Eversource (formerly NStar, which was formerly Boston Edison, which the building was named for) and contains active electrical substations. Since Potters Stables was "connected by telephone" by 1890, the site's long association with technology is fitting.

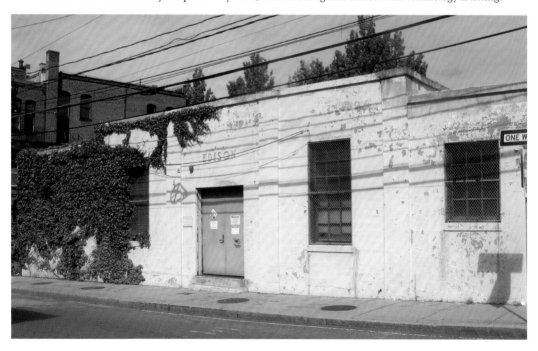

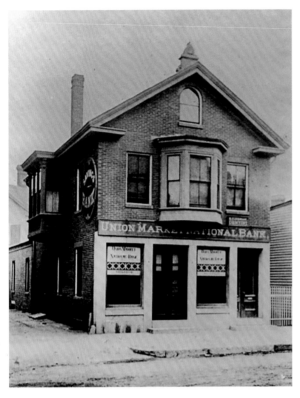

NOYES BUILDING TO SANTANDER PARKING LOT: The Noyes Building, a historic property of the Massachusetts Historical Commission, stood at 8-10 Church Street and housed Herbert Goding the plumber and Byron E. Searle the dentist in the 1800s. The Noyes Building was also the original home of the Union Market National Bank in 1873, and although no buildings are listed at 8 or 10 Church Street today, the site is now a Santander Bank parking lot flanked by the stunning tree shown in the bottom photograph. Santander bought Sovereign Bank and re-branded the bank as Santander in 2013.

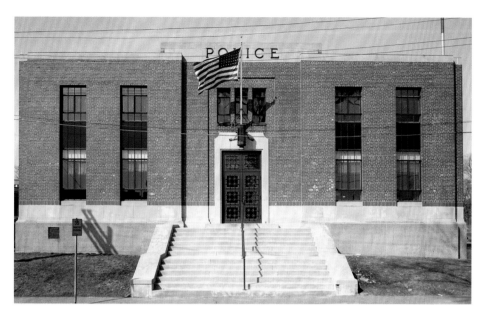

POLICE STATION: The first Watertown police were employed in 1864, replacing constables. The police department in the 1880s employed two regular policemen, seven special policemen and twenty volunteers. Imprisoned debtors paid for their room and board at the police station jail, which contained a "Tramp Room." In the early 1900s, police operated an ambulance to minister to the "sick, injured and unfortunate persons." In 1933, a police station was erected at 34 Cross Street (Cross Street north of Main Street was renamed John Sonny Whooley Way after a long-time, revered police sergeant). It was said that it was built atop a quicksand bog. A jail with six men's cells, one women's cell, and a juvenile room was established in that police station. Police officers used to make regular rounds of businesses in the Square to make sure their back doors were locked. The police station moved from the Square to 552 Main Street in 2010. Today's police department employs sixty-eight officers, thirteen civilians, and twenty-six crossing guards. Both photographs are courtesy of retired police detective Peter Seminara's photo collection.

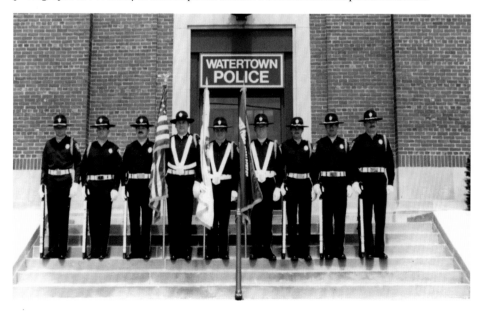

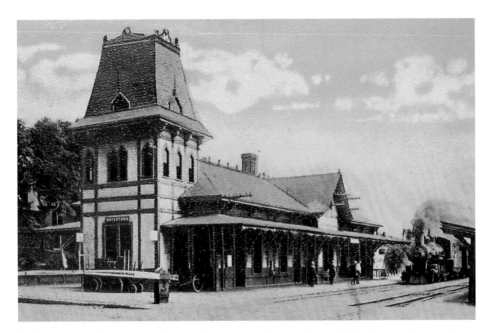

B. & M. R. R. STATION TO GRAY'S DISCOUNT HOUSE: In the 1870s, Union Horse Railway cars traveled from Watertown Square to Boston from 6:05 AM to 9:55 PM. It took an hour for the cars to complete the trip. The top illustration shows the Boston & Maine Railroad Station Steam Engine Train Depot in the late 1910s. The depot at one time provided telegraph service. Two brothers, Malcom A. and H. S. Gray, owned the Gray block, which was built on the former site of the Watertown Square Boston & Main Railroad Station next to the John MacIntosh Coal Company (which also sold wood). In 1922, although the building still looked like a train depot, Malcolm A. Gray operated the M. A. Gray Company discount house at the site, selling second-hand furniture, appliances, and televisions. The bottom photograph from Tresca's Eating Place owner Stephen Tresca's photograph collection shows Gray's Discount House in its heyday.

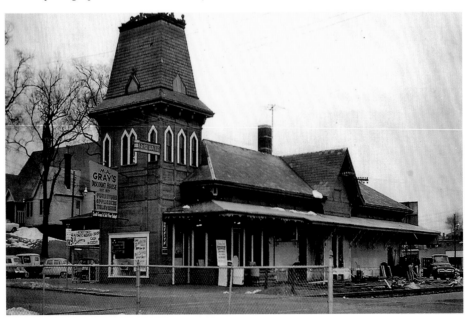

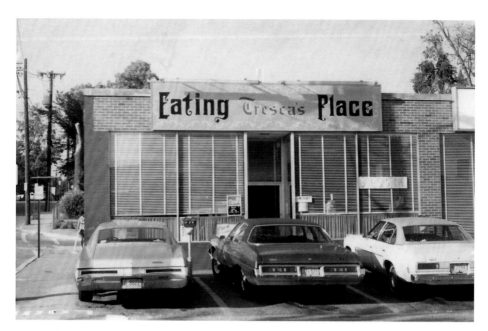

TRESCA'S EATING PLACE, 1977 AND 2017: Tresca's Eating Place was established at 25 Church Street in 1977 by brothers Tom and Ron Tresca. The property was formerly McManus Ice Cream and Penguin's Ice Cream, and was bought at auction. The Trescas kept the original ice cream parlor stools (reupholstering the gold to green), and bought booths at a Chinese restaurant auction. Now Tom's son, Stephen, owns the restaurant, which opens at 6:00 AM every morning and is known for its Full House Omelet. Customers like Mario and Sal have come nearly every single day since the restaurant opened. The grass, trees, and flowers in front of the stores were added in the 1990s; before that there were just parking spaces shown in the top photograph. One visitor to Tresca's had an unusual request—he brought his own sausages and asked to have them grilled there. When management refused, he brought the sausages to the laundromat next store and tried to cook them in the dryer.

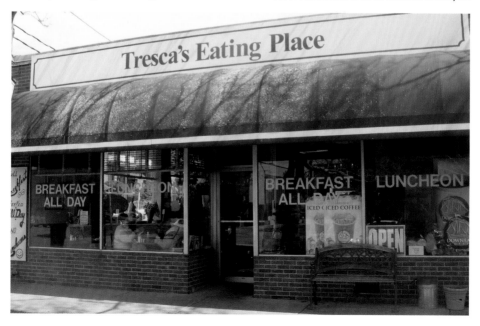

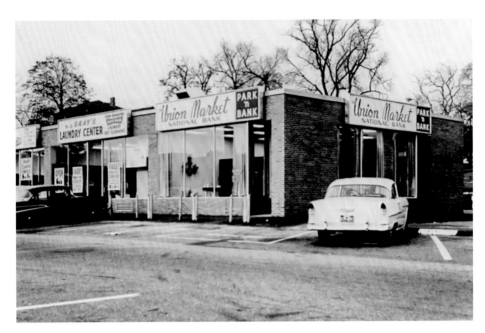

GRAY BLOCK: Grays Laundromat has been in business at 25 Church Street since 1960. Murray MacLean bought Gray's Laundry in the 1970s, and has always used Maytag washers and dryers, although none of the original models remain. Owner Rose Caloiero opened Salon Sabrina (to the right of the laundry in the bottom photograph) in 1992 at a former site for a printing store. The salon offers a full array of hair and nail services, as well as a number of unique treatments, such as cosmetic tattooing and eyelash extensions. Takayuki Koei Kuwahara has been providing acupuncture services in Watertown since 1989, the Culia Ki Clinic Acupuncture and Shikiku shown below provides Hari (Kototama) Japanese-style treatments. The top photograph shows the earlier days of the Gray Block, when the Union Market National Bank's "Park'n Bank" branch once stood next to the original Gray's Laundry Center. (Courtesy of the Charlie Morash photograph collection.)

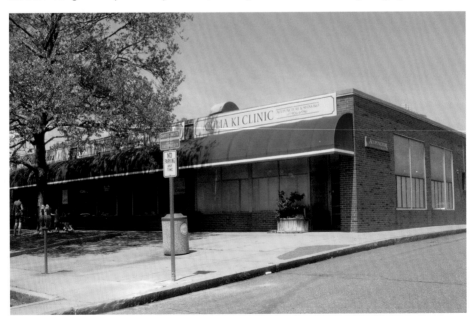

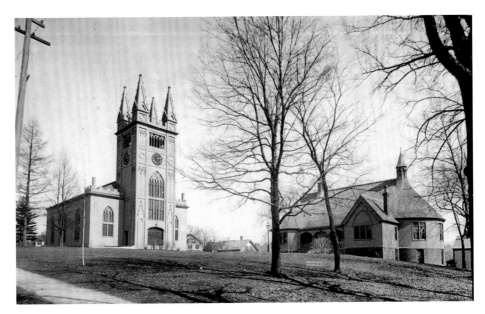

FIRST PARISH UNITARIAN CHURCH: The First Parish of Watertown is one of America's oldest congregations, and traces its history to the settling of Watertown in 1630. The parish has worshipped in eight different meetinghouses since its beginning. The parish became Unitarian in 1819. The First Parish Unitarian Universalist Church of today resides at 35 Church Street in a parish house designed by architect Charles Brigham and built in 1889. In the 1960s, the church housed Vietnam draft dodgers. The top photo was taken prior to 1975, which was the year that the parish's majestic gothic church building on the left was removed. There is now a drive-through branch of the Watertown Savings Bank where that building used to be. The bottom photo by church member/Watertown photographer Carole Smith Berney in 2014 shows how the original parish house building has been renovated to become the church of today. The church entrance has changed, the trim enhanced with a striking red design, and beautiful flowering bushes now greet congregants and visitors, but the original 1800s steeples and gables still remain.

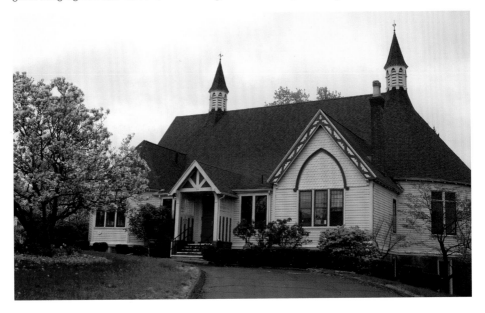

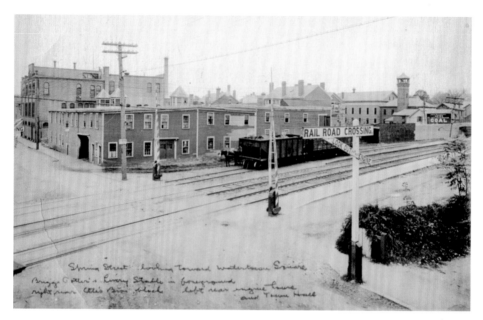

Spring Street looking toward Watertown Square, Briggs Ellis's Livery Stable in foreground, right front Ellis's Brick block, left rear engine house and Town Hall

RAILROAD CROSSING ON SPRING STREET TO PARKING: Spring Street in Watertown Square was a hub of business in the early days, with businesses like John Ross' Carriage and Wagon Factory (which built a buggy that weighed only 37 pounds), Jim Madden's Grain, Henry Rusell's Wallpaper, Wing Wah's Chinese Laundries, Orrie Hinchley's Bicycle Shop, Leroy S. Eaton's Press and Lang's Drug Store. In the mid-twentieth century, Buckley & Scott was considered one of New England's oldest automatic heating companies. The Italian Club also had their headquarters at 13 Spring Street. It was estimated in 1966 that 2,878 pedestrians visited Spring Street each day. Today if you visit Spring Street in Watertown Square, you can buy unique furniture imported from Italy at Italian Design Interiors, have your hair styled at Magaline's Salon, or relax at Orchard Massage Treatment Center or Elan Massage. A railroad sign in the earlier photograph admonished passersby to "Look out for the engine," while the sign directing vehicles exiting the street's public parking lot nowadays states "Right turn only."

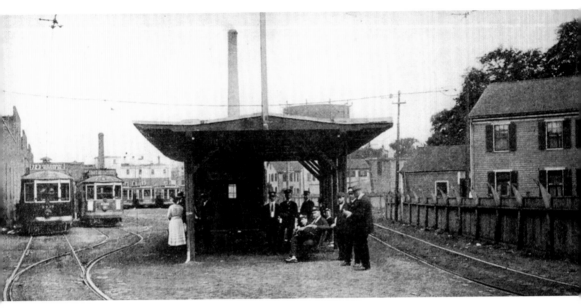

WATERTOWN YARD TO MBTA PARKING AREA: A variety of trains, buses, trackless trolleys, and street cars have passed through Watertown Square throughout its history. Passenger train service by horsecar from Watertown to Boston began in 1857. The Nonantum Horse Railway ran from the Spring Hotel to Newton. In the 1800s carriage fare cost 15 cents. There was also a terminal and passenger depot for the horse car line on Church and Cross Street (once known as Pudding Lane). Engine, coal, baggage, and passenger cars were housed there. Electric street railway service soon followed in 1894. At the turn of the 1900s, Watertown Yard on Galen Street housed six railroad gates with winches that opened and closed whenever trains approached. At one time, the yard served Green Line "A" and "D" Branch trolleys. These trolleys were discontinued in 1969 and replaced by the 57-bus service to Boston. The top photograph from 1916 shows the Watertown Yard waiting area, tracks, trolleys, businesses, and surrounding homes. The 2017 photo shows the same area, now used as public parking.

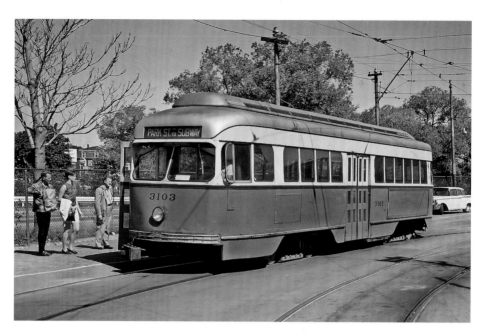

STREETCAR IN 1965 TO BUS IN 2017: Roger Puta's 1965 photograph shows the Massachusetts Bay Transportation Authority (MBTA) streetcar 3103 boarding at Watertown Yard. Watertown Square transportation has come a long way since an electric car ride to Newtonville cost 5 cents in 1898. The first trolleys had open passenger cars, and did not run in snowy weather. In 1900, the Newton Street Railway Company installed double tracks on Main, Galen, and Arsenal Streets. The Boston Elevated Company began operating buses in 1926. In the 1950s, it still only cost a nickel to travel from Harvard Square to Watertown Square. There were no Charlie Cards back then—street car operators had change-making machines that attached to their belts for collecting fares. You can still see the tracks in the 2017 photograph with modern-day MBTA buses awaiting their routes in Watertown Yard, but the tracks are no longer in use.

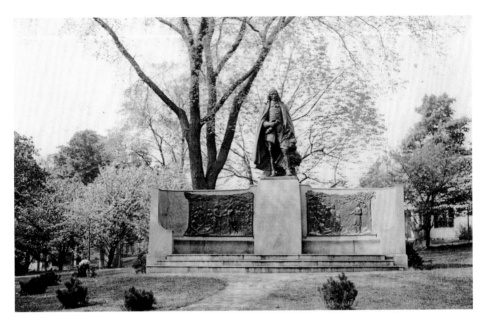

FOUNDER'S MONUMENT, 1936 AND 2017: The Founder's Monument on Charles River Road displays a statue of Watertown founder Sir Richard Saltonstall, with a plaque on each side depicting Roger Clapp's landing and Minister George Phillip's anti-tax protest of 1632. The monument and bas-reliefs were sculpted by British Sculptor Henry Hudson Kitson. The monument was completed in 1930 for Watertown's Tercentenary celebration, originally dedicated in 1931, restored by Daedalus, Inc. and officially rededicated by the town in 2009. George Frederick Robinson (G. Fred, Watertown Historical Society president from 1930-1949) raised 30,000 dollars for the creation of the bronze monument. MDC landscape architect Arthur A. Shurcliff's photograph from 1932 (courtesy of the Massachusetts Department of Conservation & Recreation Archives) shows private homes that used to flank the monument, while the bottom photograph from 2017 shows the apartments now behind it on Riverside Street.

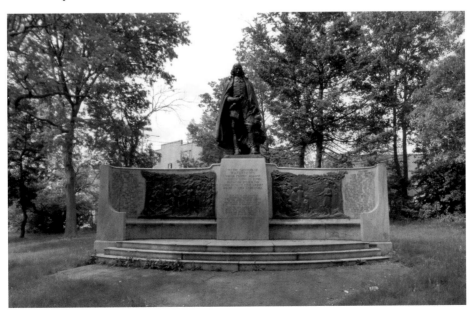

BENJAMIN ROBBINS CURTIS PLAQUE: The Curtis House on River Parkway in Watertown Square was the birthplace and home of Benjamin Robbins Curtis (1809-1874). Curtis became a Supreme Court judge, most famous for his dissenting opinion in the Dred Scott Case. A bronze marker memorial, shown in the top photograph, was dedicated to him along the Charles River in Watertown Square. That memorial was stolen in 2010, but was replaced with a granite plaque set in the in the same boulder, as shown in the bottom photograph. Memorial Day flags are festively displayed surrounding the modern plaque.

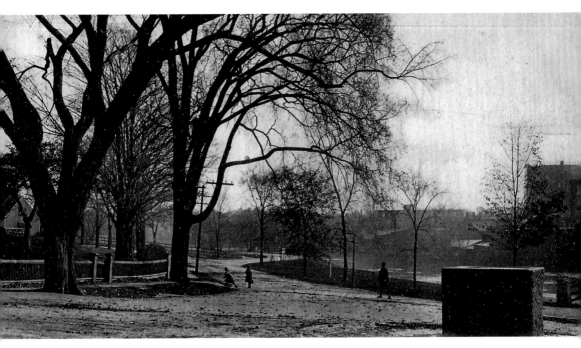

WATER TROUGH TO HOOD RUBBER MONUMENT: Next to the Watertown Square dock, a stately monument, often surrounded by flags, commends Watertown Hood Rubber staff who served as veterans of World Wars for their loyal service. This monument (shown in the bottom photograph) used to be in East Watertown near the Hood Rubber plant, but was moved to the Watertown Square location when the Watertown Mall was built at the Hood Rubber site. The top photograph of the area from 1905 shows a watering trough in the area where the monument now stands. This solid granite horse trough was installed in 1897 and weighed seven tons.

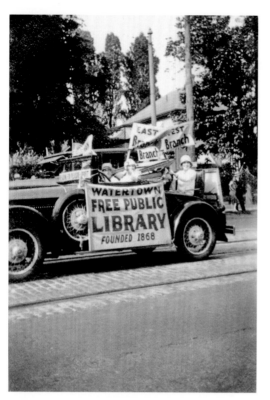

PARADES, 1930 AND 2017: Watertown Square has hosted splendid Memorial Day celebrations for revelers young and old for many years. Bands, dancers, town officials, civic associations, and, of course, veterans, parade from Mount Auburn Street to Saltonstall Park. Townsfolk always come out with lawn chairs and relax on the Square and closed-off streets to watch. A unique tradition associated with the parade is the provision of free grave flags for Watertown relatives of deceased veterans. A parade in 1897 was celebrated with a State Senator delivering the Declaration of Independence, followed by an afternoon of baseball, jumping, and races. From Bluebells twirling their batons in the mid-twentieth century to festive floats like the one in the top Tercentennial parade photograph from 1930 of the Watertown Free Public Library showcasing their new branches, the parade has been a bastion of celebration of Watertown life. In the bottom photo from 2017, Sparky the Fire Dog is joined by children of firefighter Shane Gleason in a float that teaches about fire safety in a fun way.

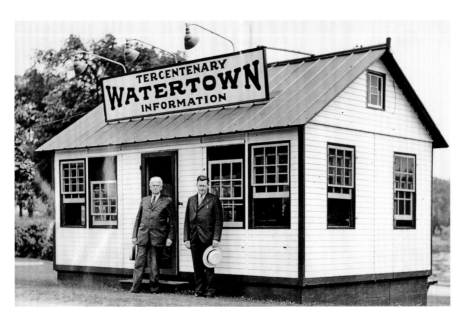

TERCENTENARY BOOTH TO SIGN: The Tercentenary information booth (shown above) for Watertown's 300-year birthday in 1930 was the only one of its kind in Massachusetts. The photograph shows Tercentenary Committee Chairman Fred E. Crawford and Executive Secretary John Colbert. The Elks concert in Saltonstall Park was one of the highlights. Watertown's 350-year birthday took place in 1980, and the Chamber of Commerce and Watertown Mall threw a fabulous party. Called "Discover Watertown," the celebration took place (of course) in Watertown Square, with the area closed off for traffic so the town could revel in the food, music, and historical events. The bottom photograph displays the sign commemorating the founding of Watertown erected by the Massachusetts Bay Colony Tercentenary Commission. Stay tuned for Watertown's 400-year birthday celebration in 2030!

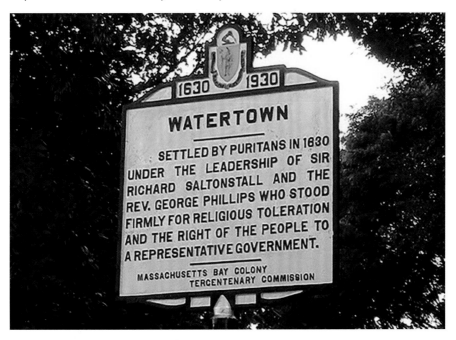

GENERAL MACARTHUR VISIT TO AUTISM AWARENESS: Watertown Square has been the site of a great number of civic and special events. General Douglas MacArthur was honored in Watertown Square when a special plaque was delivered to him by Watertown Selectman Roy Papalia. Watertown resident Charlie Calusdian, who was born in 1933, remembered standing in the Square when General MacArthur received his plaque in 1951. The top photograph is from the Watertown Women's Club collection. A current celebration is Autism Awareness Day, where the Watertown Autism Family Support Group install, display, and light two wooden puzzle pieces on the Watertown Square Delta each year (as shown below), "Lighting It Up Blue" to shine the light on autism awareness.

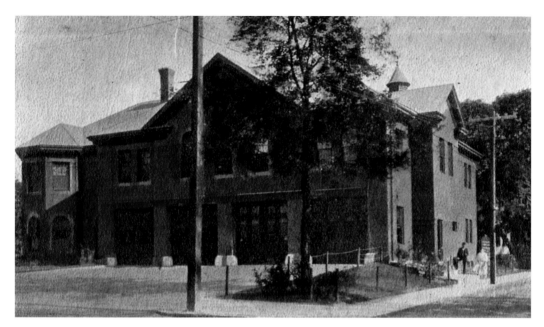

POLICE STATION TO PATRIOT'S DAY FILMING: An unassuming gent is shown standing outside the early Watertown police station in a quiet scene *circa* 1909 in the photograph above. Fast forward to 2016 ... In the busy photograph below by *Watertown News* editor Charlie Breitrose, part of the *Patriot's Day* movie was filmed at the former police station on John Sonny Whooley Way. Starring Mark Wahlberg, the award-winning film chronicled the tragic events of the 2013 marathon bombing and shootout of brothers Dzhokhar and Tamerlan Tsarnaev, including Tamerlan's death and Dzhokhar's capture that took place about a mile from Watertown Square. The slogan "Watertown Strong" was coined after the "Boston Strong" slogan that heralded from the Boston Marathon bombing itself. In 2014, Watertown Strong Calendars were given as a thank you to all town employees for their important contributions following the destructive events of aftermath of the marathon bombing.

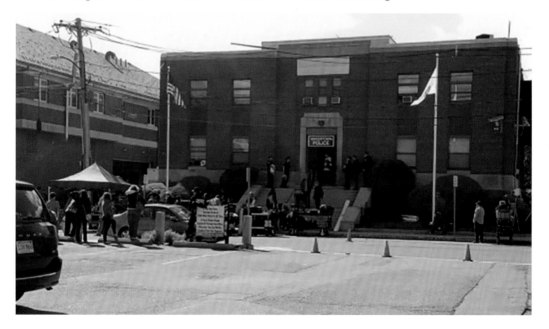

WATERTOWN ART ASSOCIATION, 1953 AND 2017: The top photograph of the Watertown Art Association 1953 outdoor show on the grounds of the Watertown Free Public Library evokes the spirit of Watertown Square as a thriving center for arts and culture. The Watertown Art Association was brand new at that point, just having been founded a year ago (their first exhibit was in the Library's Pratt Room). The Watertown Art Association currently provides free art lessons to the public and scholarships to Watertown High School seniors planning on studying art in college. Talented members of the group Karl H. Neugebauer and Marion Amato (shown below) shared some of their latest artwork in 2017 under the attractive blue umbrellas now gracing the library's front lawn.

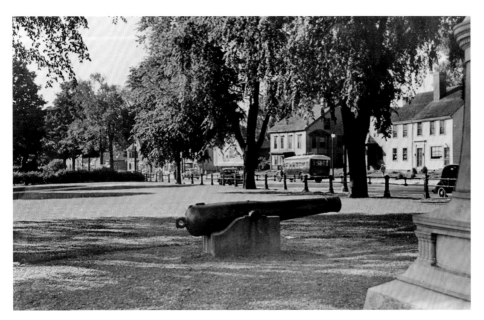

CANNON, 1938 AND 2017: David F. Lawlor's 1938 photograph of one of the cannons in Saltonstall Park displays the beauty of the park's lawn and trees. The two cannons in Saltonstall Park contain 32-pound Navy guns made by Cyrus Alger and Co. in 1849. Flanking the Soldier's Monument, they gleam as majestically as they did over 100 years ago. The cannons were moved slightly during the restoration of the Soldier's Monument in 2013, which adds unity to the display. Saltonstall Park was named after Watertown founder Sir Richard Saltonstall, who, along with Reverend George Phillips, travelled from Britain and discovered Watertown in 1630. Previously known as Main Street Park, the park had once been the site of the Titcombe and Thaxter estates, and was purchased by the town in 1882. Sports and games have been enjoyed in the park through the centuries—John S. Airasian used to be a batboy for the industrial softball league that played in Saltonstall Park in the 1950s; his father Peter Airasian was the head of the league.

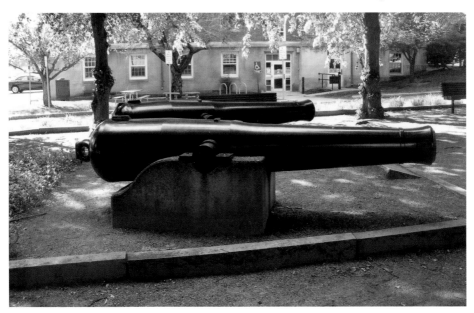

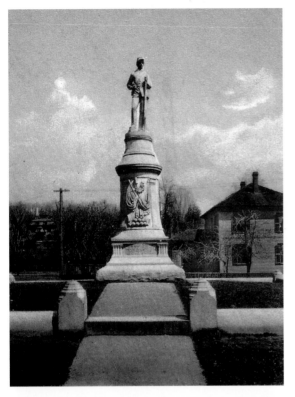

SOLDIER'S MONUMENT: The Soldier's Monument in Saltonstall Park was erected and dedicated in 1889. The granite monument stands over 21 feet tall. The pedestal is inscribed, "In Honor of the Men of Watertown who Fought For the Preservation of the Union." The monument was designed and constructed by the Hallowell Granite Company in Maine. There was a similar monument erected in another park in Maine. The Soldier's Monument was extensively restored and rededicated in 2013 through the artisanal work of conservator Daedalus Inc. and sculptor David LaRocca. The removal of the two pedestals flanking the monument made it all the more striking, as did the trees that grew up behind it, illuminating the statue with sparkles of morning light. The monument is considered a historic property by the Massachusetts Historical Commission. Saltonstall Park was famous for its town concerts even in the 1800s. Many Watertown residents flock to the park every summer now for its summer open air concerts, and the fall Faire on the Square draws concertgoers, shoppers, and apple-pie contest contestants from all over the town.

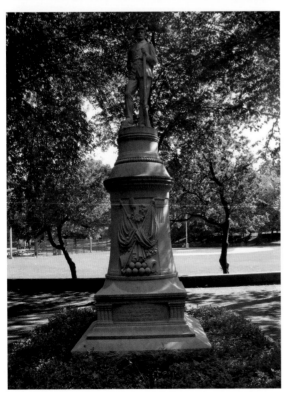

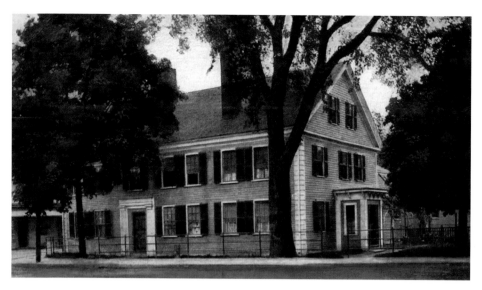

COOLIDGE TAVERN AND MARKER: The Coolidge Tavern, one of Watertown's five colonial taverns, was erected in the 1742 by ship builder William Williams and purchased by James Coolidge. The Georgian-style tavern was located on Galen Street. George Washington and his minutemen, and John and Samuel Adams, all dined there, and Washington slept in the Tavern's hotel, too. The Tavern was famous for its hot johnnycakes and the libation of its day was a hot rum and spice drink called Flip. The house was remodeled in 1840 without the low hip roof by John Brigham. In the mid to late 1800s, John and Mary Brigham and their children (including architect Charles Brigham) lived in the house, which became known as the Brigham property. The Boston Elevated Railway Company purchased the property in 1900 and demolished the house to expand the trolley tracks and erect car barns. A red brick Colonial Revival car house with a high arched opening was constructed in 1934, but closed in 1969. The marker shown below is all that remains of the Coolidge Tavern.

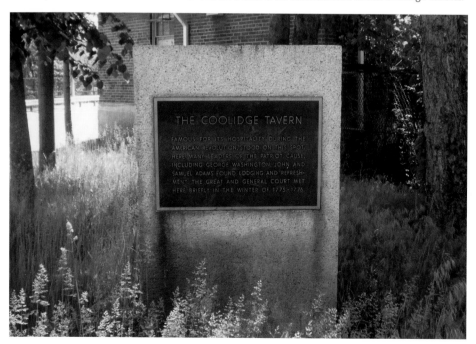

STEPHEN COOK HOUSE AND PAUL REVERE MARKER: At the start of the Revolutionary War, Paul Revere and his family once lived in the Stephen Cook House, located on the south side of the Charles River at what is currently the intersection of Watertown and California Streets. The house was also known as the Paul Revere House. Paul Revere made engravings for colonial money with Stephen Cook's son John Cook at the house. The house was demolished in 1897 and a stone was placed in 1902 marking the site. The site is now home to many people at 20 Watertown Street who live in the Watertown Square Apartments, shown in the background of the bottom photograph.